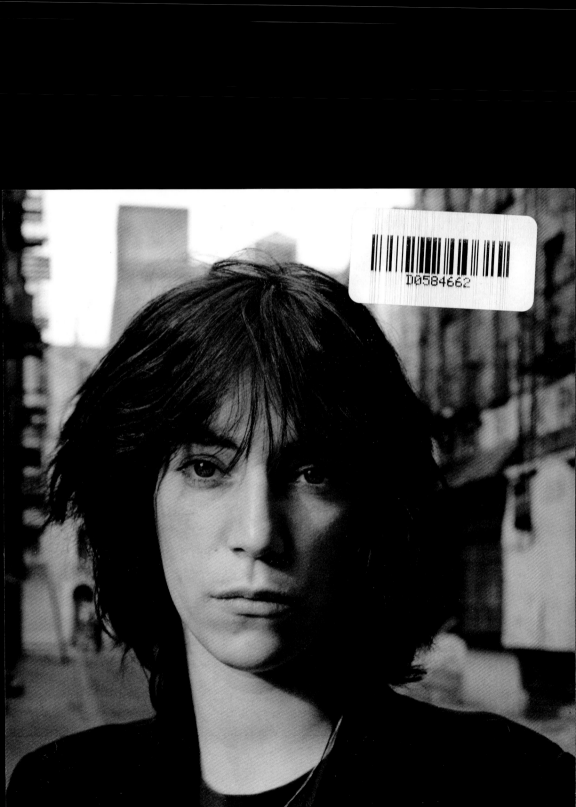

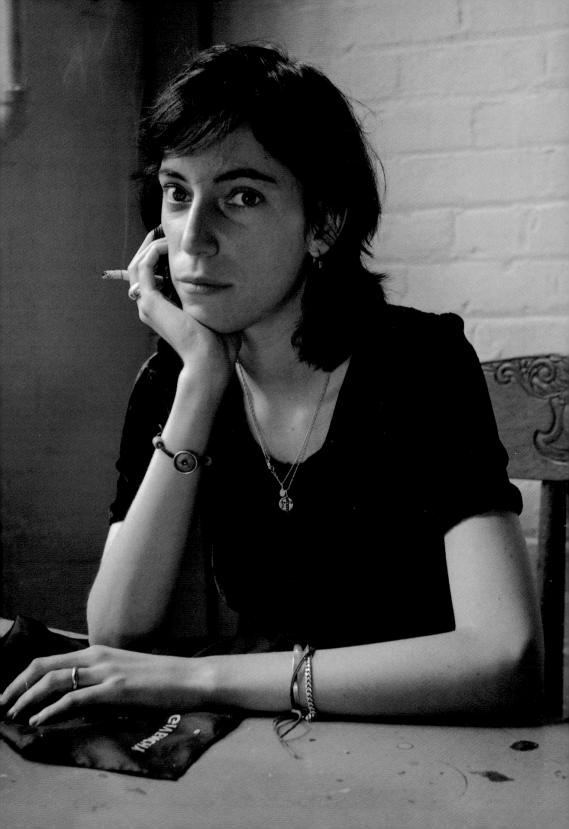

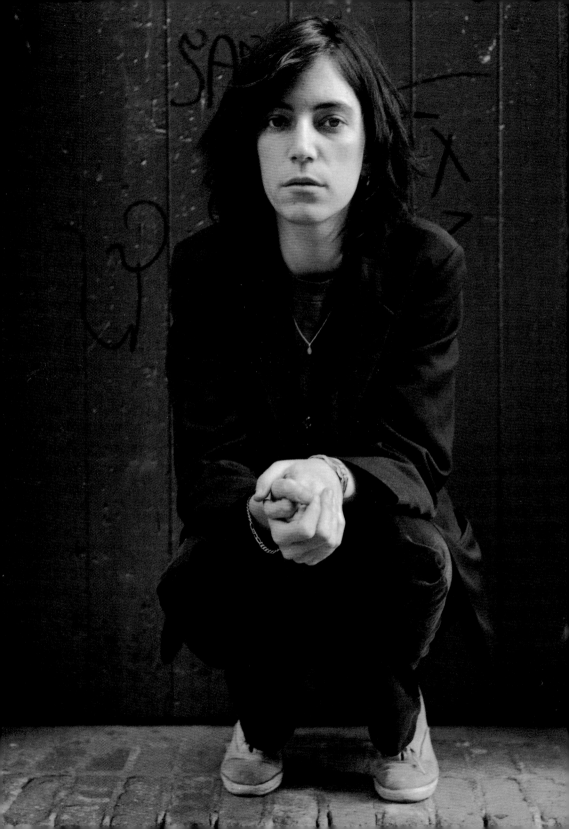

PATTI SMITH

AMERICAN ARTIST

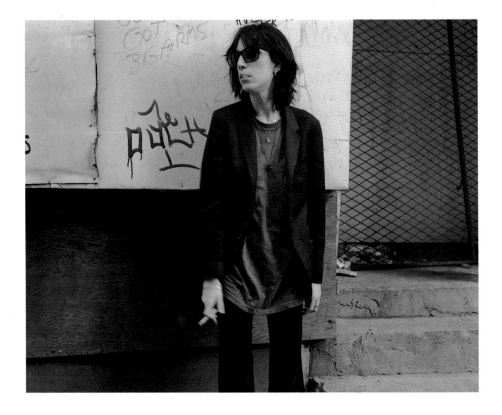

Dedicated to Patti Lee

PATTI SMITH
AMERICAN ARTIST

BY **FRANK STEFANKO**

FOREWORD BY **PATTI SMITH**
INTRODUCTION BY **LENNY KAYE**

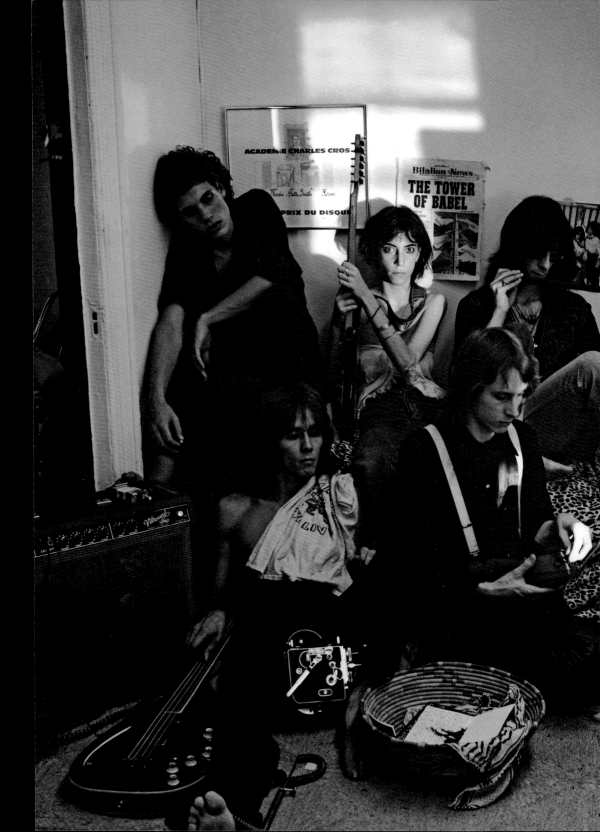

CONTENTS

PREFACE

I was heading up to Asbury Park, New Jersey, along with my high school sweetheart to see Patti Smith perform her annual birthday show, that particular year at the Stone Pony, the seashore club where Bruce Springsteen cut his teeth. The only thing highly unusual about this was that my high school sweetheart and I had just recently reunited after some thirty-five years of leading separate lives.

We arrived at the Stone Pony on a frigid December night, and Carol remarked that the full, pale yellow moon that lit up the ocean gave the appearance of a frozen Creamsicle. I grabbed my camera bag and we dashed in from the cold to meet Patti backstage. I introduced Carol to Patti, who already knew about our amazing reunion. Patti donned a wide grin and I could tell she was happy for these two old souls who found each other again after a lot of water under the bridge.

It was an exceptional night, December 29th, the eve of Patti's birthday. Patti's mother was there too, although none of us knew it would be one of the last shows she would see her daughter perform. Patti's sister, Linda, and her family were there as well. As freezing cold as it was outside, it was hot inside—packed wall-to-wall with fans waiting to share a special night with a most special artist.

Carol and I wandered into the crowd as Lenny Kaye, Jay Dee, Tony, and Oliver were taking the stage. We maneuvered to a position where I could get some live shots of Patti and her band, who were performing an inspired show. The band was cooking, and the crowd was eating it up, when all of a sudden, about halfway through the set, Patti paused and turned around to face drummer Jay Dee Daugherty.

Jay Dee started to lay down this heavy beat . . . BOOM, boom-boom, BAM . . . BOOM, boom-boom, BAM . . . Patti spun around, grabbed the microphone on the fly, and shouted out, "This one's for Frank & Carol!" Patti then tore into the most soulful rendition of the Ronettes' "Be My Baby" I've ever heard her do, and two old soul mates, for one brief moment, were transported musically across time and space to that high school gymnasium . . . and for that one magical moment . . . we were young again.

A lot has happened since that night at the Pony. It was shortly after that when I started telling Patti about this idea I had to put a book together from the photographs I made of her over a ten-year period.

This story starts in South Jersey, when I first met Patti in college in the mid 1960s, and continues up until almost 1980. The photographs included in this book start from 1970 and end around 1980 as well. These were the early days, following Patti's departure from South Jersey and her arrival in New York. These were the days in which Patti Smith evolved from the artist she was, to the artist that she has become.

On July 10, 2005, Patti Smith was decorated by the French Minister of Culture with the rank of Commander of the Order of Arts and Letters. With little fanfare a few

Photo by: Carol Reed

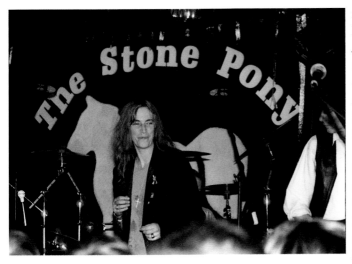

months later, Patti released her latest book of poetry titled *Auguries of Innocence*. Shortly after that, she was the recipient of the "Woman of Valor Lifetime Achievement Award" at the ROCKRGRL Music Conference in Seattle, Washington.

A few years prior to this, Patti exhibited eighty pieces of her artwork at the Andy Warhol Museum in Pittsburgh, Pennsylvania. The show and companion book entitled *Strange Messenger* was a retrospective of over thirty years of her fine art, including paintings, drawings, and mixed media pieces.

Somewhere in the middle of all this, Patti released an album that I believe to be her masterpiece, simply titled *Trampin'*. If that wasn't enough, you may have even seen her on the *The Late Show with David Letterman* holding forth and trading witty verbal gems with Dave.

So who is this multi-talented American artist? A woman who has been recognized by and worked with the likes of Bono and U2, William Burroughs, Bob Dylan, Charles Bukowski, Allen Ginsberg, Susan Sontag, Bruce Springsteen, John Cale, Lou Reed, Sam Shepard, Michael Stipe, Tom Verlaine, Andy Warhol, and Robert Mapplethorpe, to name but a few. A woman who has, to date, written fourteen books of poetry and prose, and published works of her own visual art. She has released twelve full-length albums, including the thirty-year re-release box set edition of *Horses*, the break-out record that defined her and led to a style that many would come to emulate.

Who is this artist who is equally happy in front of an audience of thousands performing her music and poetry as she is at her easel creating one of her amazing paintings, or at her computer conjuring up with the most incisive ability to manipulate the printed word with such intelligent creativity?

Who is this artist who is so worldly, having traveled throughout most of Earth's continents, having stood under the North Star and the Southern Cross? Who is so in tune with the complexities of the planet and its inhabitants, who at the height of her career chose to drop out of the limelight and move to Michigan to lead a domestic life as a wife and mother until the untimely death of her husband, after which she returned to New York to continue her work?

The story of Patti Smith's evolution in becoming one of the most important and prolific artists that America and the world has seen in decades, for me, starts back in those college days in the mid-sixties in South Jersey . . . So allow me to take you back to that place and time and share some of my recollections and photographs of a very gifted young woman.

—*Frank Stefanko*

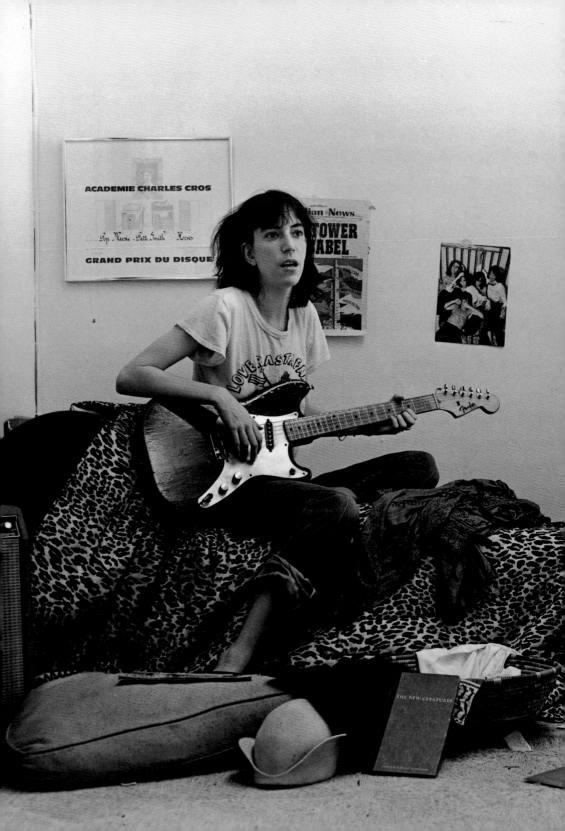

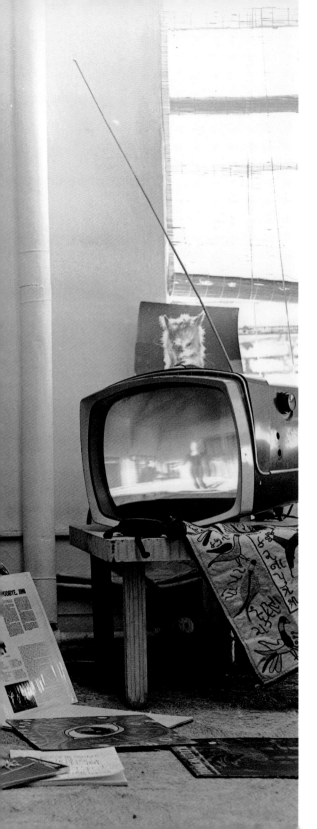

FOREWORD

When I asked Patti to write a foreword for this book, she took a great deal of time thinking about the task I requested. This great woman of words shied from expressing herself in a book titled Patti Smith: American Artist *even though many years ago in "Babelogue," she proclaimed, "I am an American artist and I have no guilt." I think, now that she is indeed that, and so much more, she found it difficult to respond to this title. Eventually, she sent the following piece, written in the time that these photographs were taken:*

I keep trying to figure out what it means to be american. When I look in myself I see arabia, venus, nineteenth-century french but I can't recognize what makes me american. I think about Robert Frank's photographs—broke down jukeboxes in gallup, new mexico . . . swaying hips and spurs . . . ponytails and syphilitic cowpokes. I think about a red, white, and blue rag I wrap around my pillow. Maybe it's nothing material maybe it's just being free.

Freedom is a waterfall, is pacing linoleum till dawn, is the right to write the wrong words. and I done plenty of that . . .

—*Patti Smith, April 1971*

INTRODUCTION

As a pre-rock youth, one of my favorite television shows was *You Are There*, which promised—through the then-miracle of sight broadcasting—to return us to events past, putting us within the camera frame, becoming part of the action. In the crowd stabbing Caesar. A random pilgrim stepping onto Plymouth Rock. Catching a piece of the Hindenburg zeppelin as it lands in flames. Sometimes you experience the happenstance of history firsthand.

It's not just a musician who makes a record. The photographer also captures a moment, time stopped an instant so it might be examined, listened to, or looked at, remembered and experienced anew. The there of then.

Portraiture is the distance traveled between casual snapshot souvenir and the artist's eye, a process of composition squaring film's two dimensions, approaching the fourth, which resides in memory. Leafing through these photographs, taken by one who was friend first and shutter-clicker after, I can feel the onrush of legacy they now reveal, skipping stones on a pond to create circles with an orbit of their own, as the sun spins off planets, and they moons.

The Big Bang, in other words, and Frank was there to record that first flash of solar flare, when we plugged into poetry's kilowatts. As a hometown running buddy from back in South Jersey-as-it-bleeds-into-Philly, he waved goodbye to Patti as she headed for New York; a unique perspective. He always caught the hometown girl in her, even as she made New York her hometown, and then as she took on the world, beginning to understand who she, and by extension we, her band, could be. A true local, Frank's lens kept making f-stop after f-stop, pulling back the depth of field, and in this particular era, that was appropriate because by the time we got to the free-form that is *Radio Ethiopia*, that's what we would call Patti: Field Marshall.

We spent a lot of hours in the practice room in those days, playing amongst ourselves, and those are the times I recollect most, afternoons and evenings working over a song with no sense of hurry, or even audience, just following its thread until it had become a song, asking for no other reason for being except to be played. On those nights we'd perform, out in pub-lick, we would hand the music off to the audience and they would return it to us, changing the way we heard it. Give and take. Trying to get the two in balance.

The contrast between seeing and being seen . . . it's not any different for the photographer, asking light to stand still for a moment, to wait a heartbeat, and then catch the downstroke.

Sometimes the light moves at its own pace, on the verge of outrunning itself, that paradox of relativity when one doesn't age, even as the universe surrounding continues its chrono-march toward infinity. Certainly the arc of our ascent could seem dizzying, intoxicating, especially when fast forward began to blur, the no-time-to-breathe of touring and the lickety-split of renown chasing us down our creative alleyways. Shutter speed is crucial.

These glimpses into our twist-and-shout across the stage, or the backstage, or back home, lets me know that we were being watched by a kindly eye, even as we attempted to not lose sight of our original purpose, which was to stay ourselves. Frank allowed us to be only that. This is why when we see him down by the shore at the Stone Pony, or along the Camden waterfront, or on South Street in the City of Brotherly Love, we greet him like an old pal, which of course he always will be—part of the family portrait.

—*Lenny Kaye, New York City, 2006*

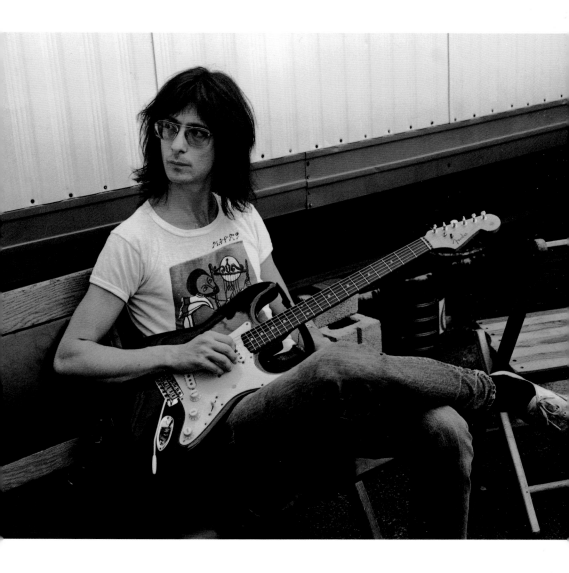

THE
COLLEGE YEARS

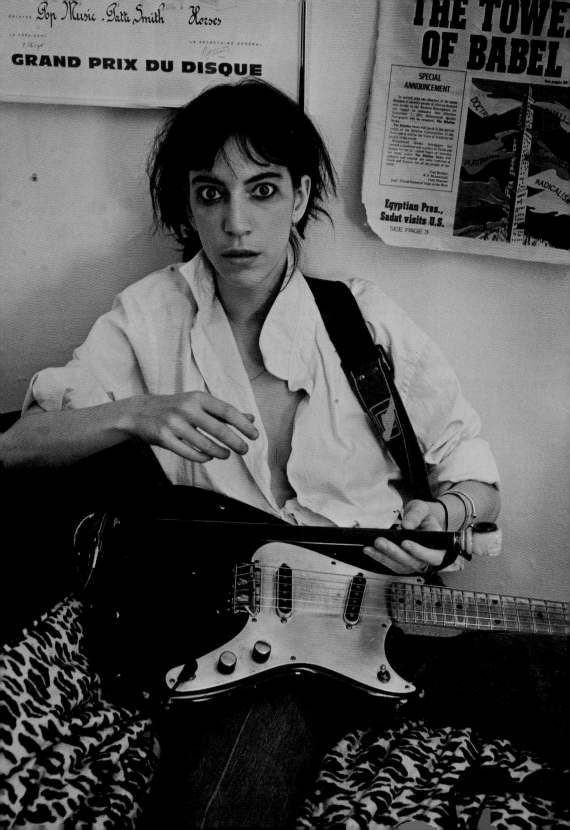

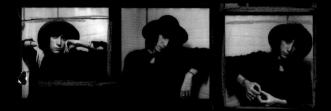

There I was sitting in a booth at the co-op of Glassboro State College, a bucolic school tucked away in the farmlands of South Jersey. Students would mingle and meet in the co-op, where you could get a cheeseburger and a soda and listen to this great old jukebox loaded with songs by the Rolling Stones, the Temptations, and Bob Dylan. I was studying the anatomy of some small animal in a biology textbook when I noticed a group of folks sitting in the next booth. These people clearly did not fit in with the rest of the conservative student body at Glassboro State in 1965. They were flamboyantly dressed, exuding a fragrance of patchouli, talking about art, music, and theater.

Suddenly, the double doors of the co-op swung open and standing there in the vacuum created by their wake was an incredible apparition, a vision in a white leather coat with long, jet-black hair flowing down her back. She moseyed in like the bad guy walking into a saloon in an old Western movie. This was the first time I set eyes on Patti Smith, and I was captivated.

Looking straight at the delightful rowdies sitting next to me, zeroing in on one of them, she fired off a greeting. "Chaps, fire of my loins, how the hell are you?"

The woman replied, "All right, Chaps. Come on over here and sit with us."

"Chaps" was the secret nickname between Patti Smith and Janet Hamill. Janet would go on to become the author of four books, a poet, a painter, and a performer, releasing CDs with her band, Moving Star. She would also remain a lifelong friend of Patti's. But back then, she and Patti were fresh young art students who called each other "Chaps."

When I saw Patti for the first time bursting through that co-op doorway, I was determined to get to know her. At that very moment, I knew I wanted to become friends.

* * *

At Glassboro (now called Rowan University), I was taking courses in photography and working a lot in the darkroom. I came out for air one day and ran into Patti on campus. Finally, I mustered up the nerve to introduce myself. Those pale blue eyes of hers were electric and, as I discovered later, extremely perceptive. Within seconds of meeting someone, she could look right through that person and figure out what they were all about. Somehow we hit it off instantly and became fast friends. As we were talking, Patti started heading toward the arts building.

"Come and see what I'm doing," she said.

I followed her into a studio where several people were sculpting. As she showed me what she was working on, I tried to imagine this slender, porcelain-skinned slip of a woman chipping away with a chisel and a hammer at this gigantic block of stone. She seemed so ethereal to me I was convinced she would spend a million years on that chunk of rock. But she kept at it, and in the course of my visits to the arts building, I witnessed the emergence of a male figure in stone. I also saw her doing watercolor paintings, and she walked around campus with her sketchbook as a constant companion. Patti wasn't just putting on a show with her attitude, her white leather coat and eccentric friends; she really was an astute, intelligent artist who worked very hard at her craft.

As we spent more time together, her list of talents kept growing. She invited me to see her perform in a school play called *Juno and the Paycock,* by Sean O'Casey. Playing the lead opposite another student, a serious fellow thespian named George Perce Faunce, she had the whole auditorium laughing. It was a very clever script. Words were bantered back and forth with such natural ease on her part. She's a sculptor, a painter, and an actor, I thought in amazement.

Patti really struck me as an unfathomable person, but what impressed me the most was that she was so

worldly. Her knowledge extended beyond the confines of Glassboro and South Jersey. She had a command of both the spoken and written word, much of which came from her love of foreign languages and far-away places. She read a lot of decadent French poetry and started writing her own, deeply influenced by Arthur Rimbaud and Charles Baudelaire. I'm sure most of the student body had never even heard of those names.

Barely twenty at the time, Patti went to Paris for a short visit, which was adventurous when most people in our world didn't leave the boundaries of the state. One of her professors gave her sixty dollars to bring back some French perfume for him. I'm not sure if she ever bought that perfume and God knows what she did with that money, but I did get a letter from Paris written on the worst toilet paper I had ever seen. That first trip was her invitation to a voyage, a wild and rich experience opening up her electric embrace of life.

* * *

Patti lived in a town called Mantua, New Jersey. I visited the Smith home a lot in those days and knew her father, Grant, her two sisters, Kimberly and Linda, and her brother, Todd. I became very friendly with her mother, Beverly, who ran a restaurant in a five-and-dime store. When my high school friend Ken Tisa was home for the holidays, we would spend time with the Smith family on Christmas Eve. I valued my relationship with them because they seemed so politically and culturally aware of the world outside of our cloistered hometown.

This worldly outlook probably fed Patti's restlessness to get out of the South Jersey farmlands. Throughout our college days, she had her eye on the Big Apple. She talked about New York often. Dylan was there. The folk singers we listened to were there, along with many other artists and writers. It was the place to be. But for the time being, we had to make do in South Jersey, and Patti had the imagination to

make life interesting.

I remember running into her once at the Cherry Hill Mall in a very middle-class conservative neighborhood. With feathers poking out of her hair, Patti was wearing some kind of cloth wrapped around her body like a sari, walking through the shopping center with a friend. People turned their heads to look. Who was this exotic person? Was she from India or Bali or some other faraway place? It was a performance, and Patti was a walking piece of art in the middle of the mall.

She could make the most mundane task an adventure. During college, I had a job delivering canned whipped cream to restaurants. One day, Patti wanted to ride in the truck so I picked her up and we drove all over the South Jersey countryside. I made stops at little farm towns and old Victorian-style communities. Riding along with me on my route, she absorbed the landscape and the people, inhaling the textures and sounds. Her imagination was boundless. She would conjure up stories about the history of South Jersey, or think for a minute and say something profound like, "It's hard to imagine that just a few million years ago this was all under the ocean!" Any journey with Patti was special. We could have been on the Orient Express.

Occasionally, we made it out even farther. Just across the Delaware River, we found our escape in Philadelphia. At the Philadelphia Museum of Art, we visited the Rauschenbergs, the Picassos, and the Van Goghs, as well as the Eakinses and Wyeths.

Patti would stare at the works for long stretches of time, saying "Yeah, I knew what he was doing," or "That artist was thinking about that." She would spin stories for me. It was as if she were climbing into the paintings and feeling the pigments. There was some cosmic texture that found its way into and through her blood. I remember the most beautiful look came over her face while she stood transfixed at *Peaceable*

From patti smith
To. FRANK STEFANKO .

past present
future
candles .
burning bright
I think it's your
BIRTHDAY
I send a Salute
+ xx
patti .

Kingdom by Edward Hicks. After she gazed at it for a long time, she just looked at me and smiled.

Beyond whatever paintings and photographs we saw in the museum and art galleries, we also did crazy things in Center City Philadelphia. In the very posh Rittenhouse Square area, we climbed the trees and watched wealthy ladies and gentlemen coming out of the Rittenhouse Hotel or the nice restaurants and shops lining Walnut Street. Well-dressed people would look up, surprised to see two out-of-place, neo-artsy, quasi-hoodlum kids up in the trees looking down at them. Another time, Patti got it into her mind that she wanted a bloodstone ring; it became a mission. We scoured the city, hunting through jewelry store after jewelry store. Patti used to call these shenanigans "goofin."

Our most memorable trip to Philly was on November 6th, 1965. The Rolling Stones were going to play at the Philadelphia Convention Hall and I knew that the Stones—especially Mick Jagger and Keith Richards—fascinated Patti. This was one of their first visits to Philly during the British Invasion, and I figured I could score a few points with her if I got tickets. She was blown away when I invited her. Her rakish heroes were coming to town and she was going to see them. Although we were pals, this was sort of like a date and I didn't have wheels so I borrowed an old red-and-white Nash Rambler from a guy I knew.

It was a cold night and I was dressed to the nines from my yellow paisley shirt, black leather, South Philly-style, three-quarter-length coat, English-cut "fake" suede jacket, on down to my very pointy, kill-a-cockroach-in-a-corner boots. Patti was draped in her floor-length white leather coat, and her hair looked like black ink running down her back.

In those days, there wasn't any security at rock concerts. Rows of metal folding chairs were arranged in front of the stage. We sat about three rows back. Opening the show were great Motown acts like Patti LaBelle and her group, the Bluebelles, which at the time included Nona Hendryx and Cindy Birdsong (who later became one of the Supremes). After the opening set, Patti and I stood on the chairs—as did everyone else—to get a better view. After a brief break, the Stones attacked the stage. There, right before us, in the flesh, was Mick, wearing an English-cut suede jacket (real, of course) and a yellow paisley shirt! How did he know?

We had never heard anything like this sound in our lives. This wasn't the Rolling Stones on our record players or in that co-op jukebox. This was Mick, Keith, Brian, Charlie, and Bill, big as life, with monstrous amplifiers. We were consumed. We were rocking and rolling and dancing on the seats when Patti suddenly remarked, "Do you notice how Bill Wyman never cracks a smile?"

"Oh, sure. Stone-face Bill Wyman." I recognized that look in her eye and knew she was up to something.

"Just watch this." Patti jumped down off her seat and walked right up to the edge of the stage. Folding her arms, she started staring at Bill Wyman. She had the balls to stare him down until he lost it and cracked a big smile.

It was one hell of a party. I vividly remember working up such a sweat that when we left the hall and went back out into the freezing night air, the sweat froze in my hair and on my face. It didn't matter though; we'd just seen the Rolling Stones, and Patti got Bill Wyman to smile.

With Patti around, pretty much any time, any place, any thing became interesting. She needed to be fulfilled, to absorb life in her own way. As a young artist, she was a clean sponge, loving life, exploring art, going on treasure hunts, goofin' on people, seeing live concerts. Eventually though, rolling through the South Jersey countryside or tramping through the streets of Philadelphia just wasn't enough.

Neither of us had talked about leaving college, but one day she was gone, and not too long after that, so was I. For Patti, there was only one place to go—New York City.

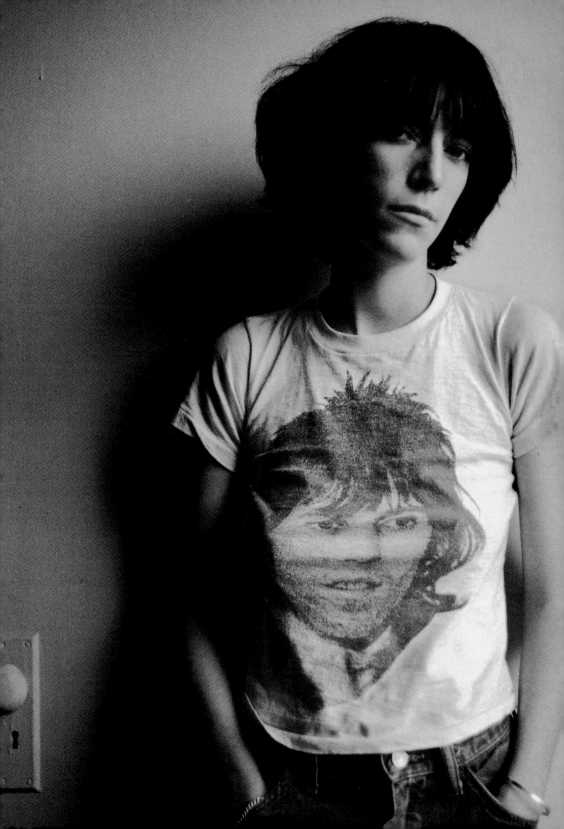

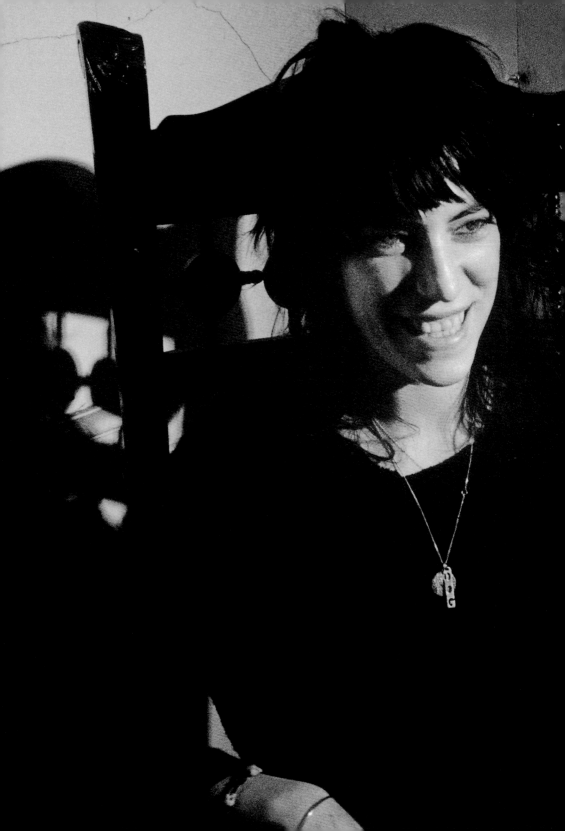

WEST 23RD
STREET

There were three of us back in high school who were considered artists: Ken Tisa, Richard Cobb, and myself. Ken and Richard were so much better at drawing than I was; they were the reason I threw all my energy and art knowledge into photography. After high school, Richard went to Vietnam and Ken went off to Pratt Institute in Brooklyn. Ken and I kept in touch and often saw each other when he came home to visit his parents. While I was in college, we would meet up at a coffeehouse on the Rutgers College Camden campus to hear some of the blues and folk singers passing through. Patti occasionally joined me, and met Ken as well. It was through Ken, in particular, that Patti would cross paths with a significant figure in her early life as an artist.

ing that might work were all you got, so Patti and Robert moved around together from apartment to apartment. They finally settled down at the Chelsea Hotel, where they tried to trade art in exchange for a small space to sleep and bathe.

When we left Glassboro, I lost track of Patti for a while, but I was in New York frequently, hanging out with Ken and his friends, and photographing Lower Manhattan's people and places. It wasn't too long before I was spending time with Patti and Robert in their loft. Half of the space was Robert's. Necklaces with silver skulls and his sculptures and assemblages were hanging on white walls. Patti worked in the other half. Books, papers, and drawings were strewn everywhere. An early Aerosmith album sat on top of a pile of art supplies.

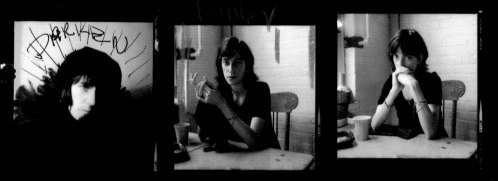

At Pratt—one of the country's best-known art schools—there was a group of young artists who lived near each other, including Ken Tisa, Howie Michaels, and Robert Mapplethorpe. When Patti got to New York, she looked Ken up and through a twist of fate discovered Robert. From their first encounter, Patti and Robert became one. They were so into each other, feeding one another artistically and spiritually. When Robert left Brooklyn, they decided to share an artist's studio in the front part of a loft on West 23rd Street in Manhattan.

Back then, a loft was simply a factory space cleared of equipment. Plaster walls and plumb-

One day, Robert and I brought out our sixteen-by-twenty-inch portfolios. Sitting on the floor, we started critiquing each other's photographs. Robert was very gracious to me, and his work was so exquisite. I admired his sense of composition and the meticulous way he approached his work. When he discussed his subject matter, I can only describe his demeanor as quietly passionate. When talking about his art or mine, he was very precise, polite, and sensitive in his critiques. I understood Patti's devotion to him and the closeness of their relationship.

Not only did she work seriously at her drawings and poetry in those days, but she also

e new contacts and met all kinds of people.
ne 1960s and early 1970s, the Chelsea Ho-
was a magical place where all kinds of raw
tive energies gathered—both inside and out
he street. Different artists were constantly
ing and going and doing. The Chelsea was
ked in artistic ambience. Eugene O'Neill,
an Thomas, Tennessee Williams, and
mas Wolfe had all lived there. William Bur-
ghs wrote *Naked Lunch* and Jack Kerouac
ned *On the Road* in Chelsea rooms.

When Patti and Robert lived there, some of
guests included Bob Dylan, Janis Joplin, and
Hendrix. For Patti, it was a time to develop
own sense of imagery and rhythm, as well as
ivate her identity as an artist.

place. I used to leave my photographs down
the street in the Chelsea Hotel lobby so people
would know my work and who I was.

Hanging out with Patti again after that bri
hiatus when she left Brooklyn was great. As a
photographer, I was reminded of what drew m
to her ever since that first moment she appeare
in the co-op doorway. I was fascinated with he
visually—the white porcelain skin, black hair,
and expressive eyes created an austere yet allur
ing look. She had cut her long hair into a Keith
Richards-style shag that dramatically framed he
face. Her presence and the incredible animatio
in her face—looking down, glancing to the side
smiling, laughing—made a seemingly simple
photo come alive.

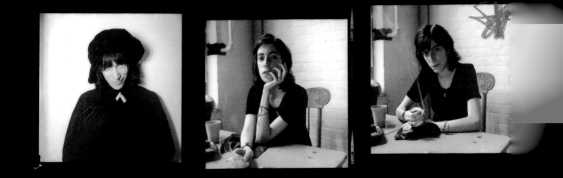

By early 1970, Patti and Robert were able to
bine their living quarters with their work-
studios at that loft on West 23rd Street. For
ort while, the neighborhood became the
of our activities. The gang would gather
re and go to Max's Kansas City, the Village,
GB's, or wherever something was happening
t night. People would meet on the neighbor-
od streets, share news of each other's success-
and generally try to be supportive. Ken Tisa,
et Hamill, Patti, or I might bump into one
other and say, "Did you hear that Zamba's in
now?" or "Kenny is having his own opening,"
or "Patti's doing a performance at such-and-such

I always gave Patti prints from our shoots
for her portfolio. Some of them have been used
over the years in various magazines and for pub
licity, but photographing Patti wasn't about get-
ting the cover of a magazine. When I printed th
pictures, seeing my vision of her transformed
into those black-and-white images made me
realize how much Patti and the camera belonge
together. Some of the best photographers in the
world have shot her because she's such a fasci-
nating subject.

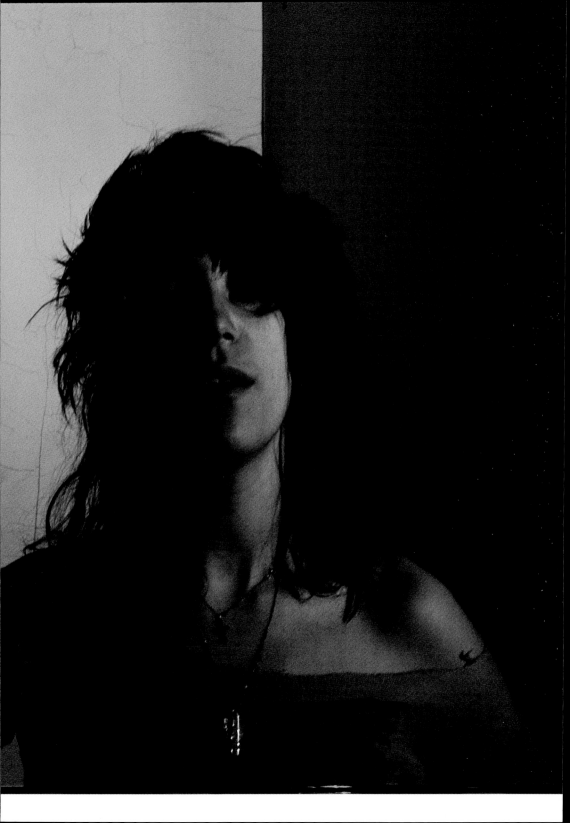

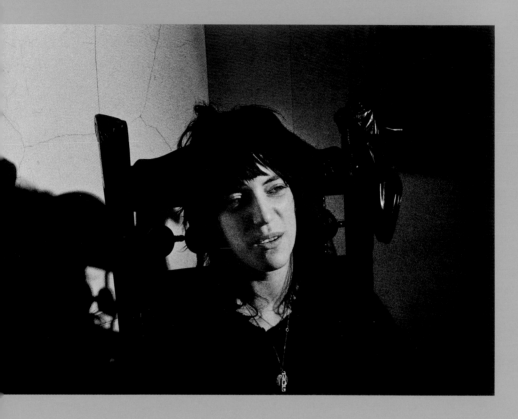

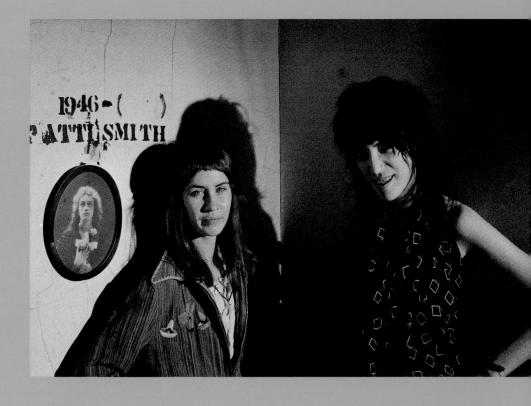

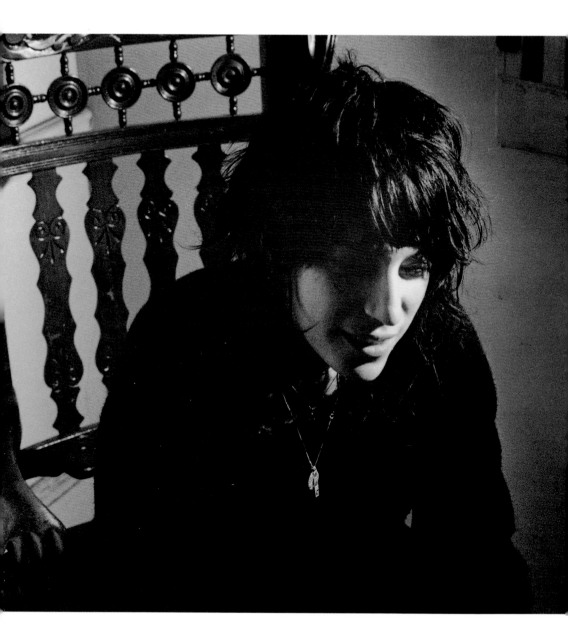

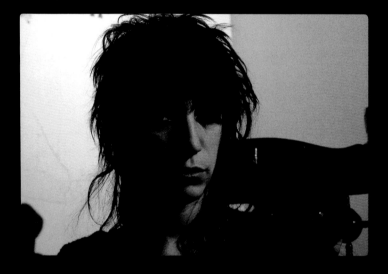

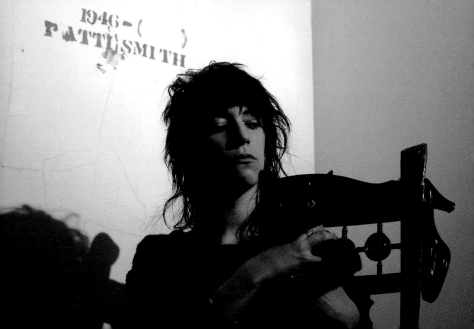

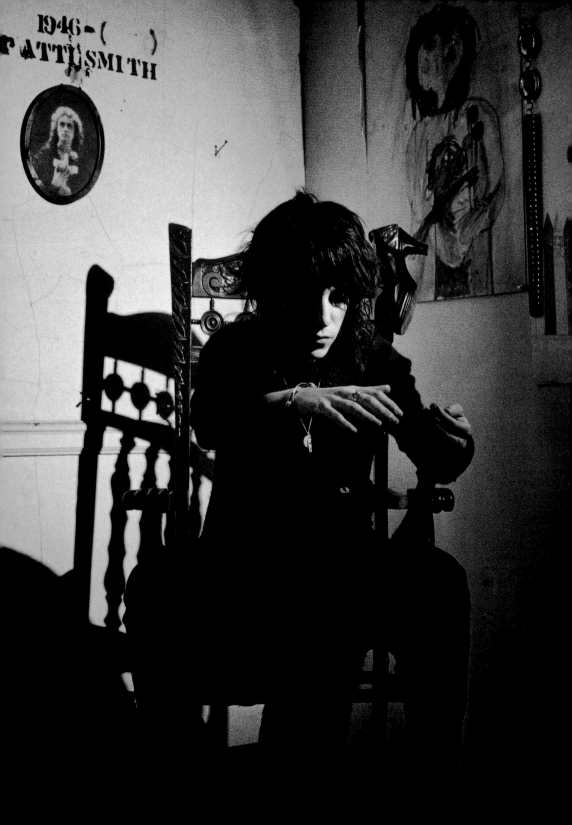

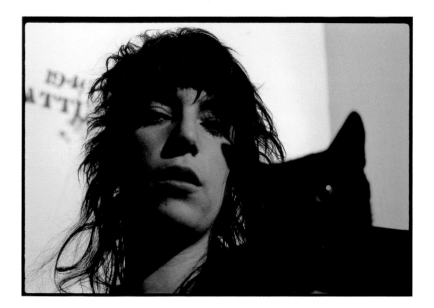

THE
ARTIST
EMERGES

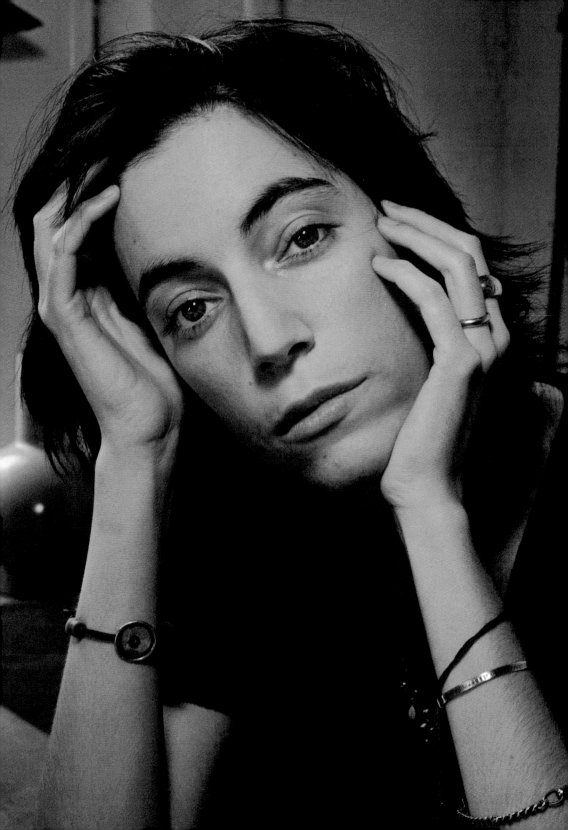

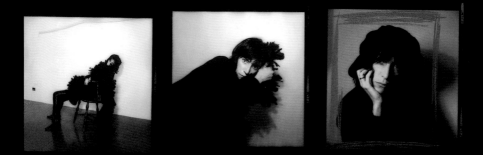

Patti's presence in the artistic world began to grow beyond her association with Robert Mapplethorpe. In 1973, she started giving poetry readings at St. Mark's Church and collaborating with Sam Shepard writing plays. William Burroughs and Allen Ginsberg respected her and recognized her potential as a fellow artist. Adding another layer to her poetry, Lenny Kaye joined Patti with his guitar, and her readings at St. Mark's became quite popular. With Lenny backing her up, she began to explore further the substance of words not simply for their meanings, but also for the way her voice could find rhythm in language. On her early albums, the richness of her images and the shapes of her sounds are captivating. Like an instrument painting with notes, Patti has the ability to do wonderful things with words.

As her circle widened, she decided that she needed more photographs for her portfolio. I certainly wanted to build up mine with additional shots of her, so we scheduled a shoot at Ken Tisa's gigantic loft on North Moore Street in Tribeca for an afternoon. I bought a bottle of wine, put on some classical music, and set up the studio lights.

I opened the windows to catch the breeze coming off the Hudson River. In springtime, a special fragrance sometimes fills the Manhattan air. It's a comforting, balmy aroma enhanced by the sun starting to warm the city after a cold winter's freeze. Rejuvenating sensations promise that summer is just around the corner. With all the good vibrations happening at the shoot, the additional ingredient of that breeze permeating the loft brought Renaissance expressions out on Patti's face.

Very relaxed and in a great mood, Patti vamped for the camera in a dress and a new Givenchy scarf she bought in Paris. This was unusual since she normally wore pants or some kind of suit. One great thing about Patti was she never fussed with her clothes. If she threw a shirt or a hat on, it immediately looked great. With music playing, we moved around the loft, standing over here, sitting over there. One of the cameras I used was an old Yashica D twin-lens reflex I bought in the 1960s for about sixty dollars. Those shots came out the sharpest.

This was one of my favorite sessions with Patti and we both had a lot of fun. The afternoon was just perfect, and the shoot was upbeat with an easygoing karma between us. She felt comfortable with an old friend. She could do no wrong in my eyes, so she was free to express herself any way she wanted. If she felt silly and wanted to act silly, or just let go like in our goofin' days, she knew I was there to grab the best of it. Viewing Patti through that lens was a treat. If I could tear my gaze away from those piercing eyes, well, then there was the whole rest of her face to enjoy.

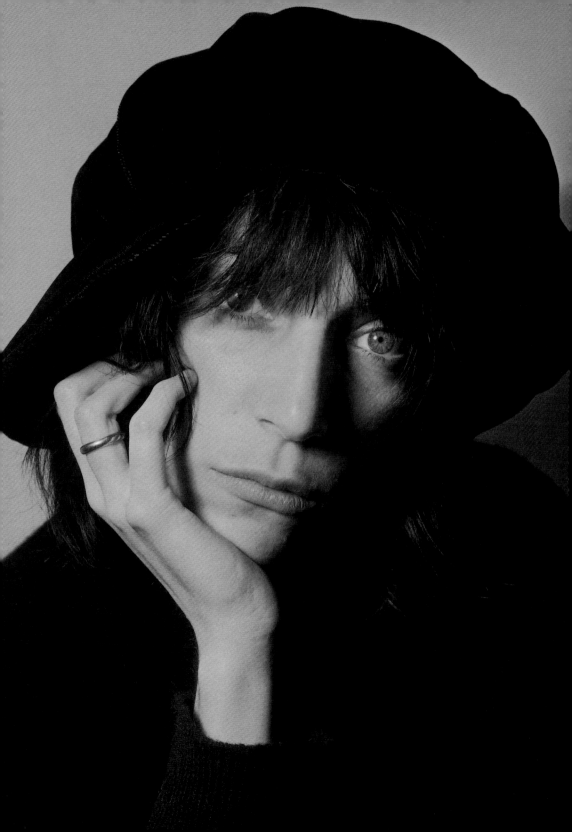

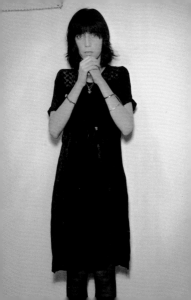

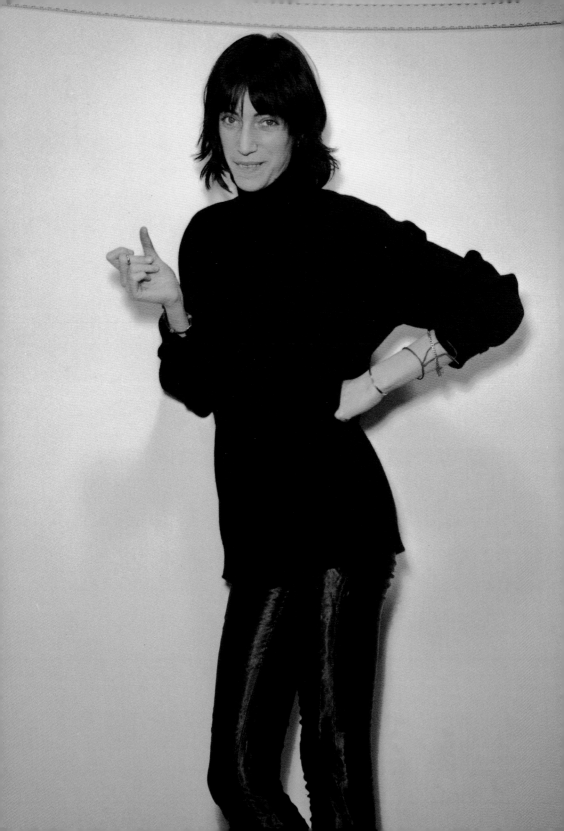

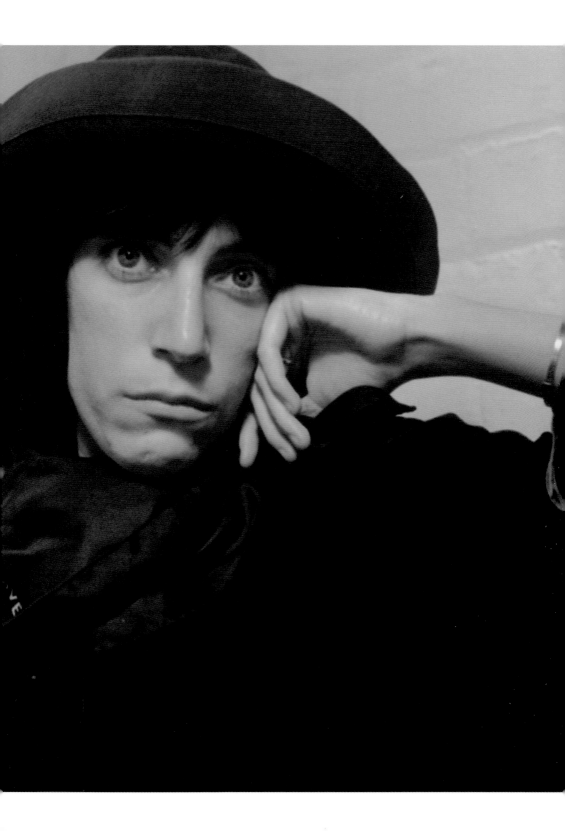

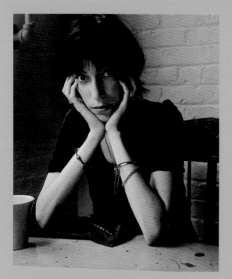
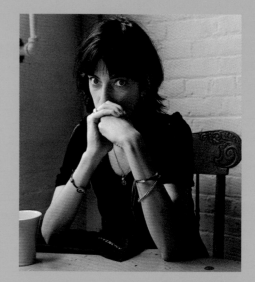

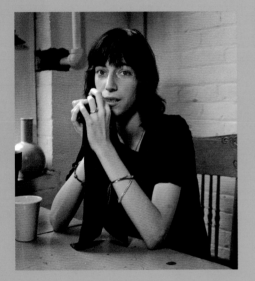
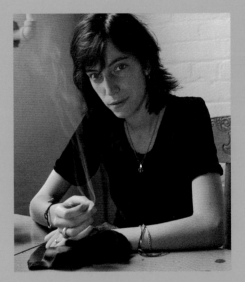

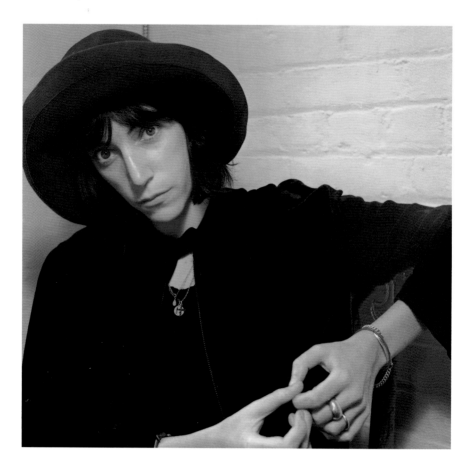

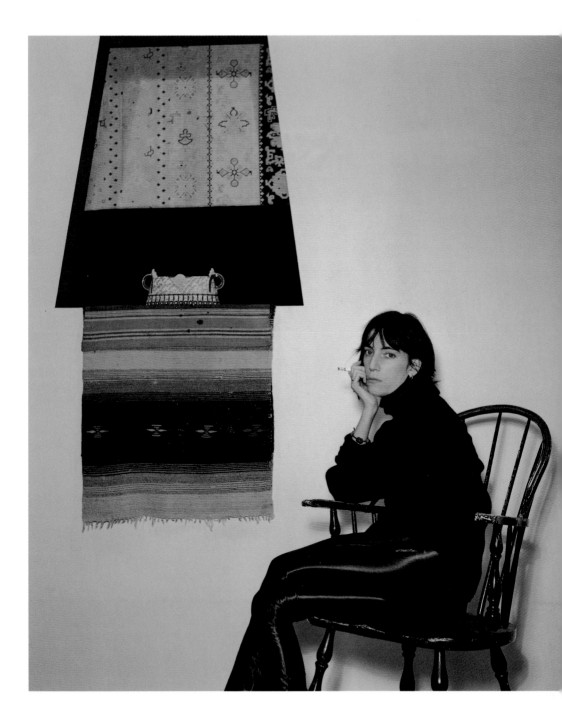

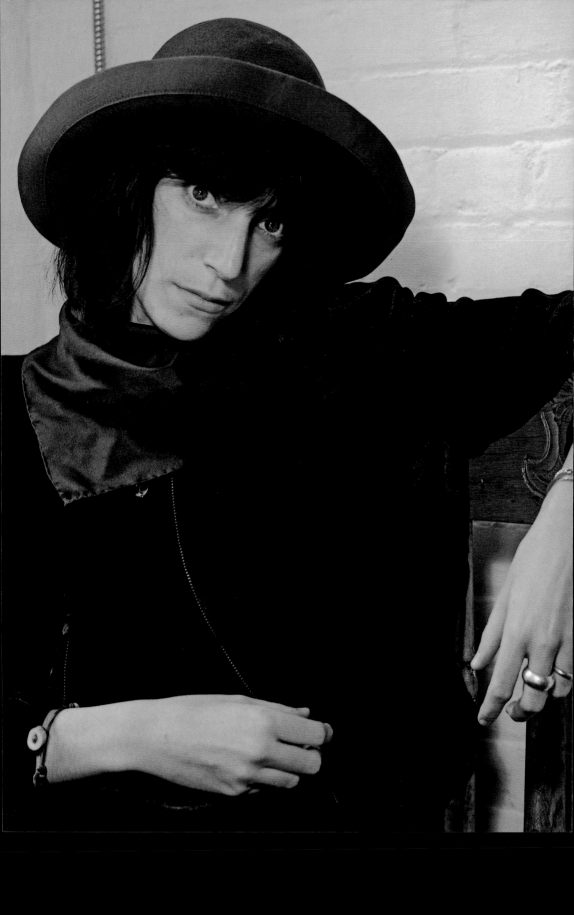

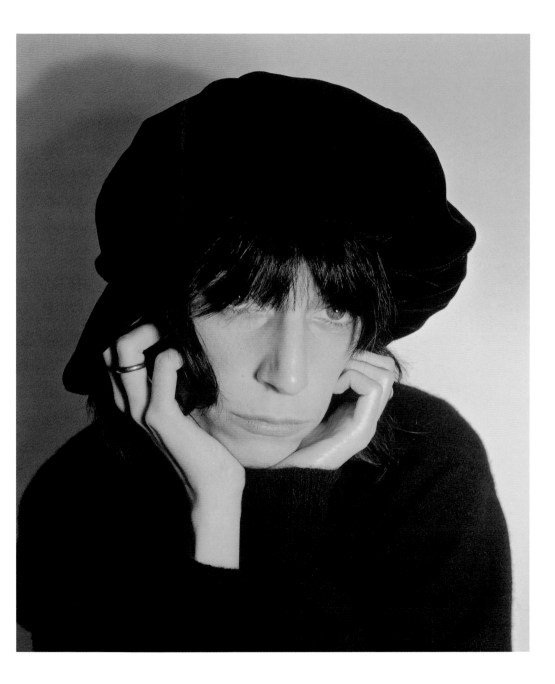

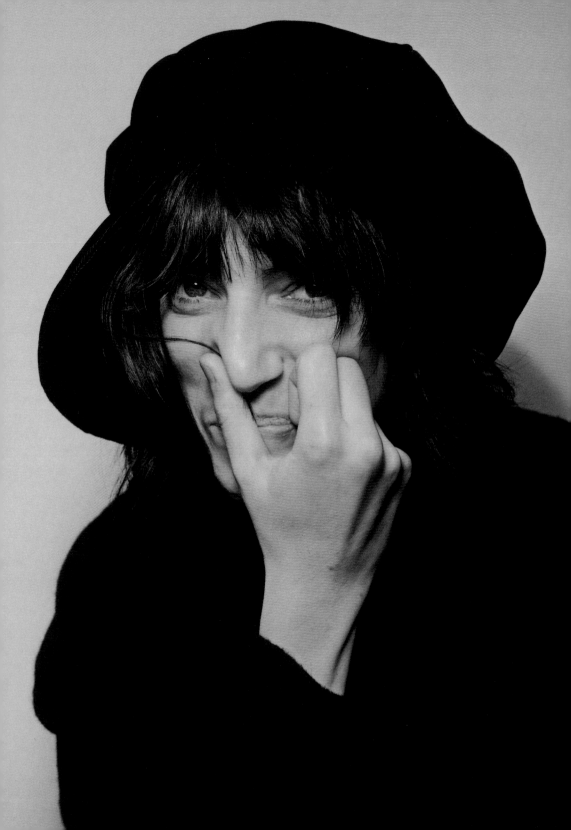

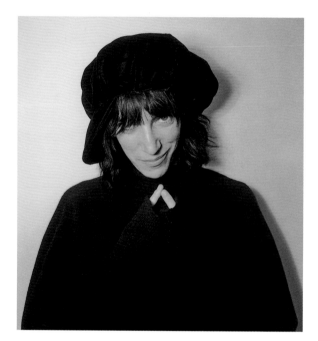

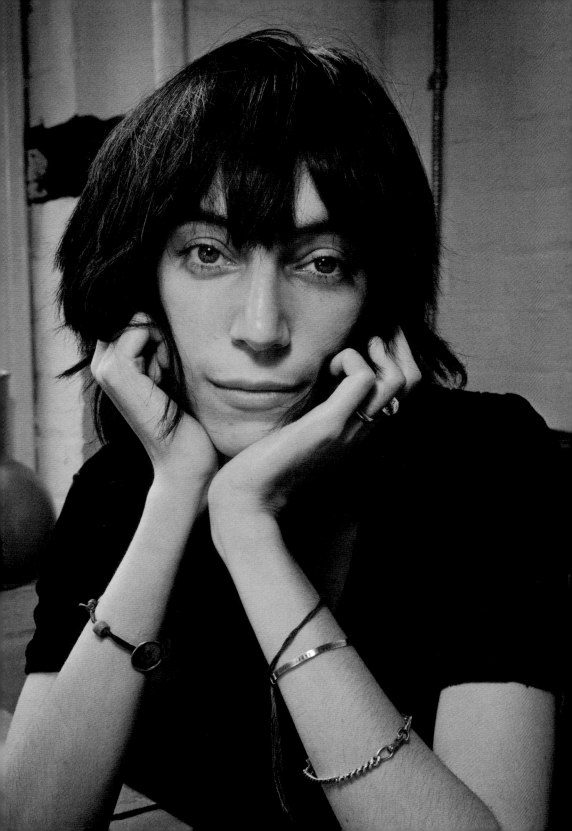

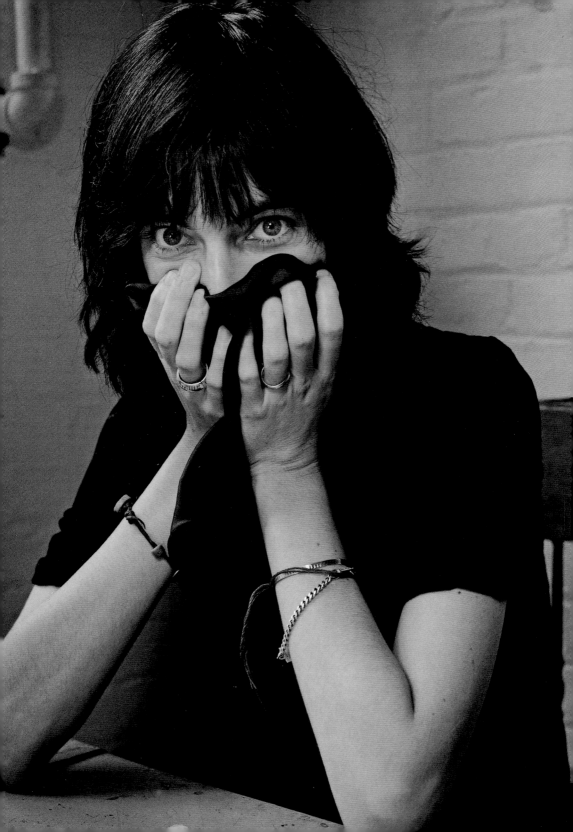

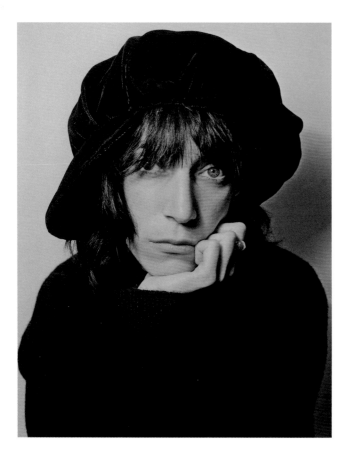

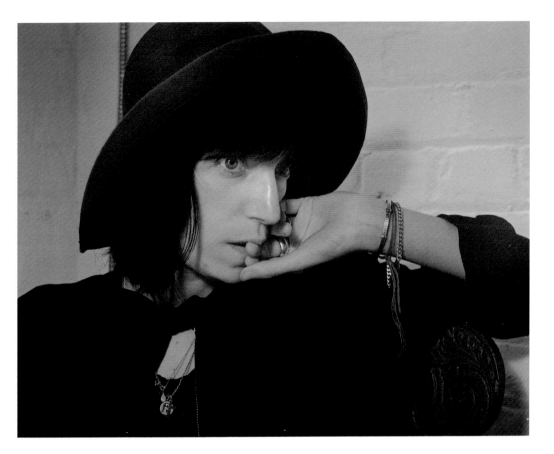

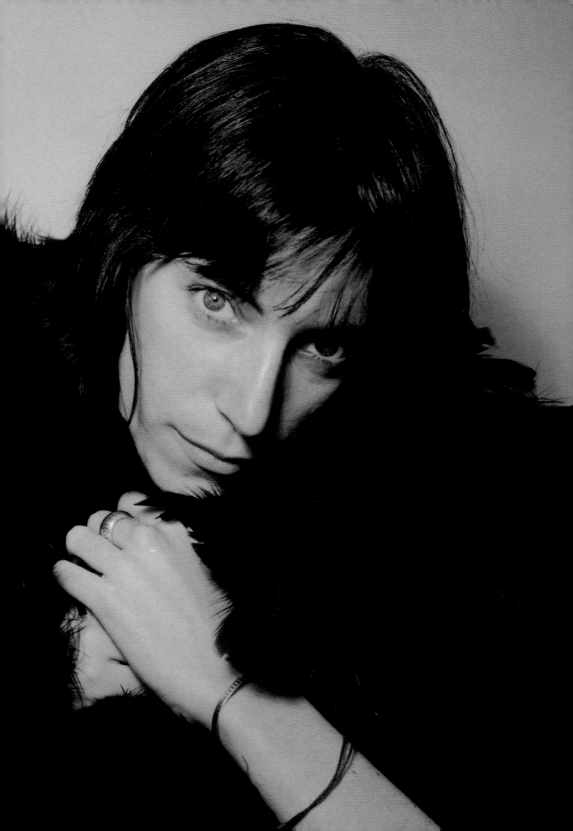

SPREADING WINGS

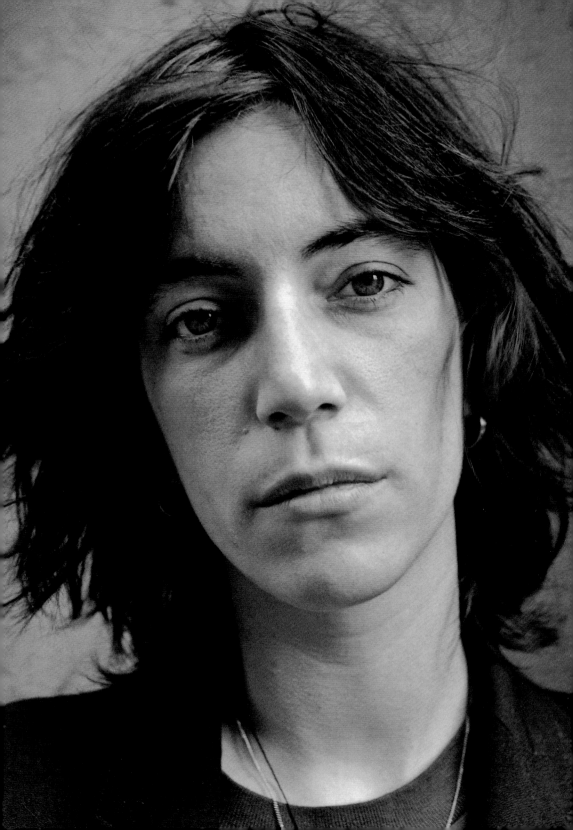

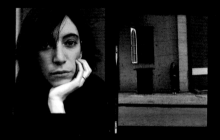

The next time I photographed Patti, she was really beginning to spread her wings. Having moved away from West 23rd after she and Robert had found themselves moving in different directions artistically and personally, she headed straight into the epicenter of "where it's at"—Greenwich Village.

In 1974, looking through the *Village Voice* nightlife section, there was always something going on. The Beatles, the Stones, and Dylan were appearing in the larger arenas, folk singers and blues guys were playing in Village clubs, and heavy metal and punk bands were entering the scene as well.

I loved going into the city on the weekends to soak up whatever art was coming out of the galleries and clubs, and to get a jolt of that special electricity found only in Manhattan. The streets of New York were charged, and right in the middle of it all was Patti Smith.

I would hear rumors on the street that she was meeting with Warhol, or doing a reading with Charles Bukowski, or hanging out at some Village coffeeshop, hiding under a big straw hat, writing poetry. One day, I mentioned to Patti that I bought a new camera and she invited me up to the Village to christen it.

I met her at her new place on MacDougal Street with my Mamiya RB67 medium-format camera. It was the most expensive camera I'd ever owned, and I couldn't wait to start working. I had preconceived what Patti's image would look like on the ground-glass screen and I was chafing at the bit to see if she would live up to my preconception. We had a spontaneous outdoor photo session in Greenwich Village.

A warm, soft wind made the streets seem alive yet lazy as we wound around the corner of MacDougal and over to Minetta Street. We found this sleepy, mostly empty, little neighborhood street and I started to shoot. It was like Mondrian meeting Modigliani. The geometry of the buildings and the repetition of their angles framed Patti's face. Standing on the sidewalk or walking down the street, Patti got right into the scene and played it beautifully, blending into the street and surroundings. Everything became a set for a photograph—graffiti-covered walls, well-worn stoops, urban metal fences. The afternoon sun was warm and glowing on her face.

I am always drawn to the eyes of my subject, and there was always so much going on in Patti's. A woman of strong opinions and emotions, she could be tough and no-nonsense in business, or fun-loving and childlike in her friendships. Like her personality, those pale blue eyes could at turns shoot fire and brimstone or soften into those of a coy and playful little girl. Inside a studio or out on the streets, the angles of her face caught the light in so many different ways, like rays dancing across the facets of a beautiful gem. We walked all over Greenwich Village that day, Patti posing wherever a nicely lit spot presented itself. I was thrilled to be out and about with my friend, Patti Smith.

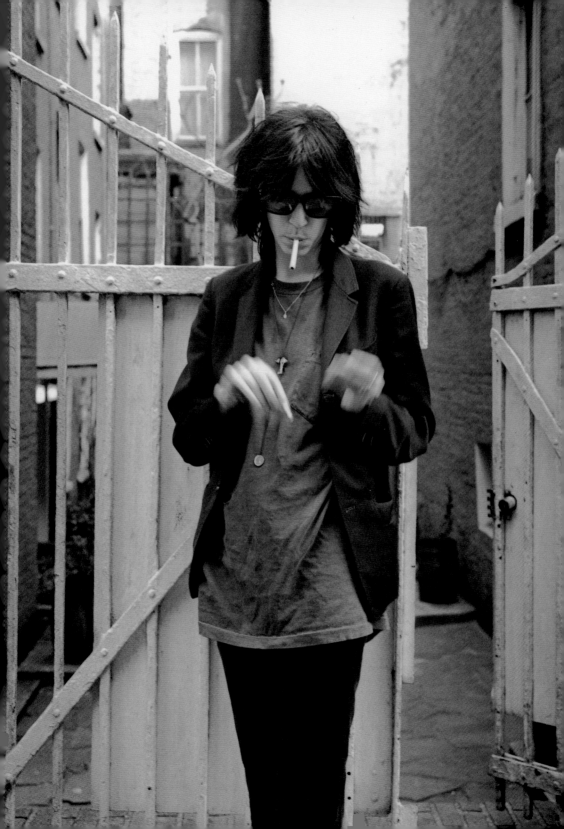

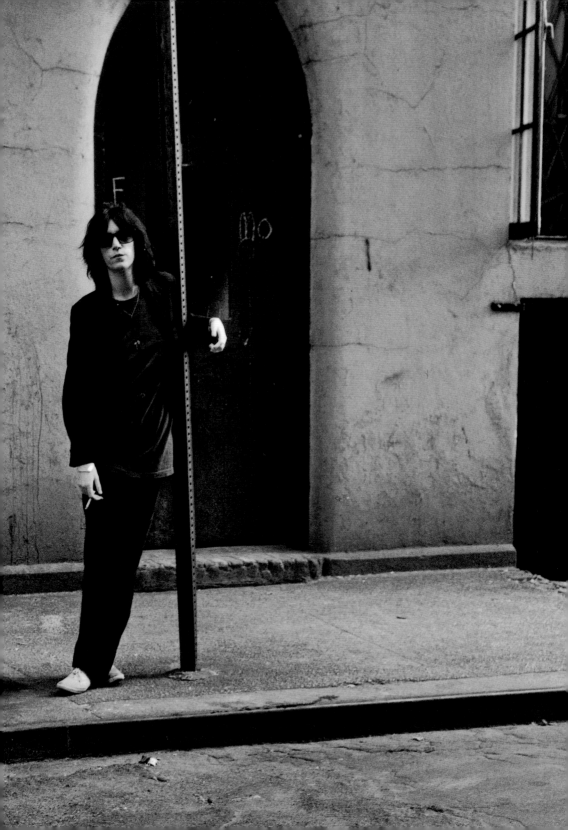

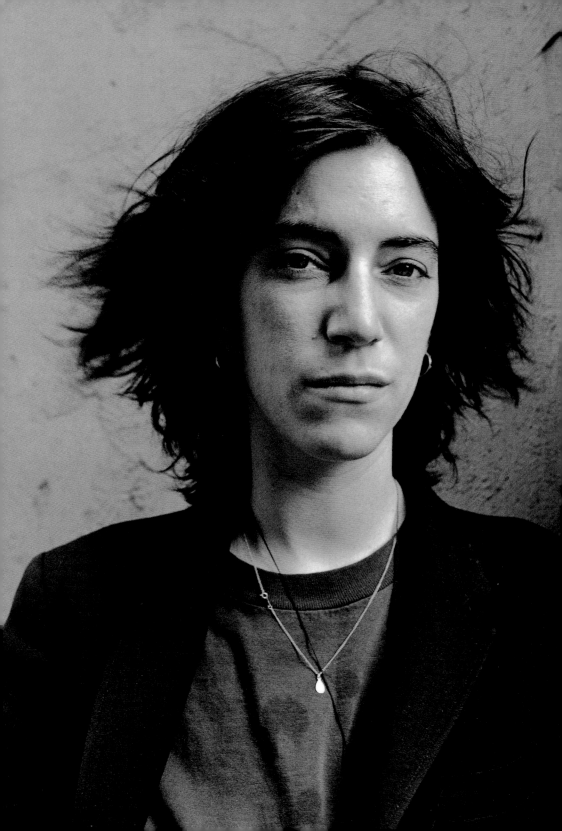

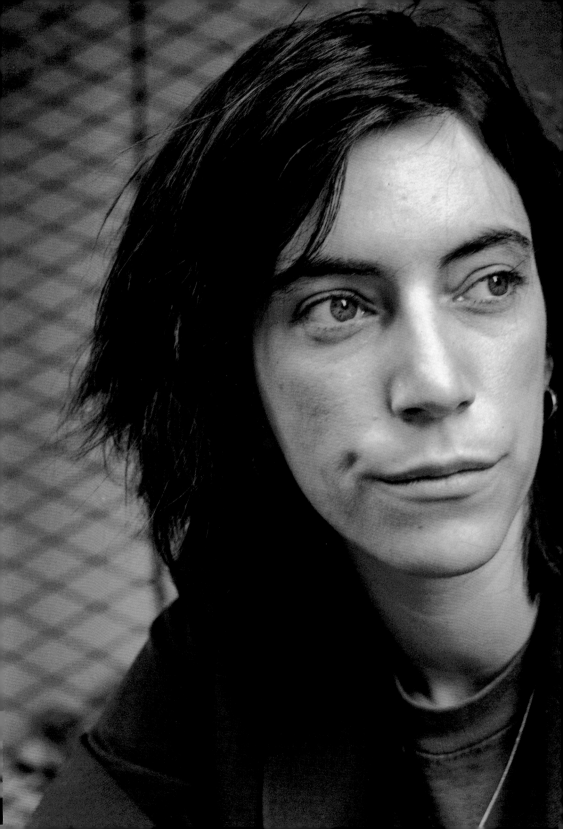

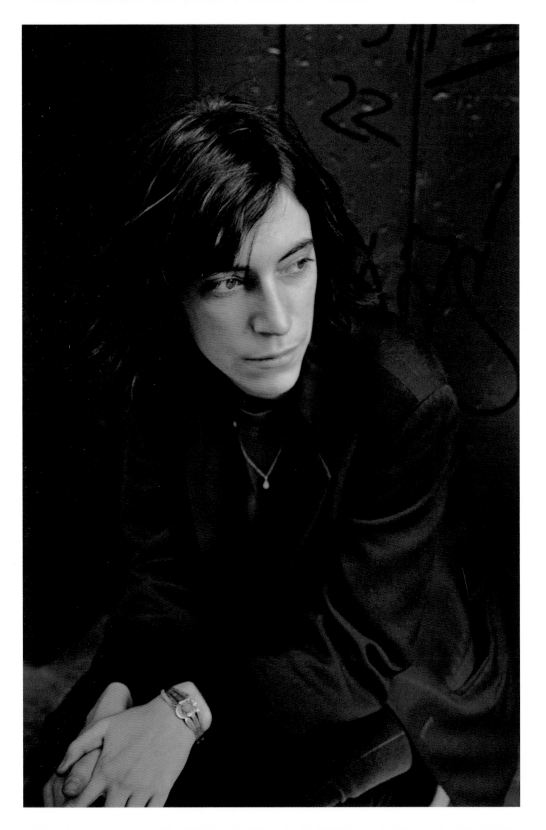

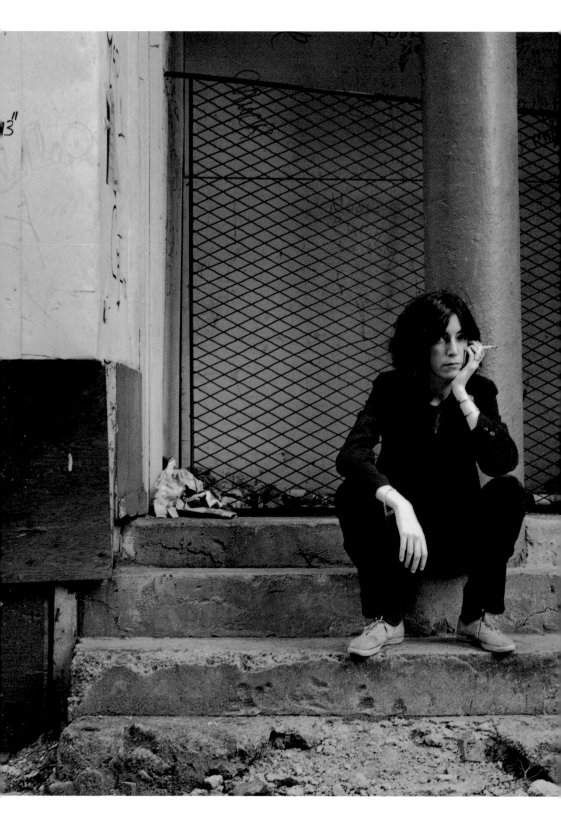

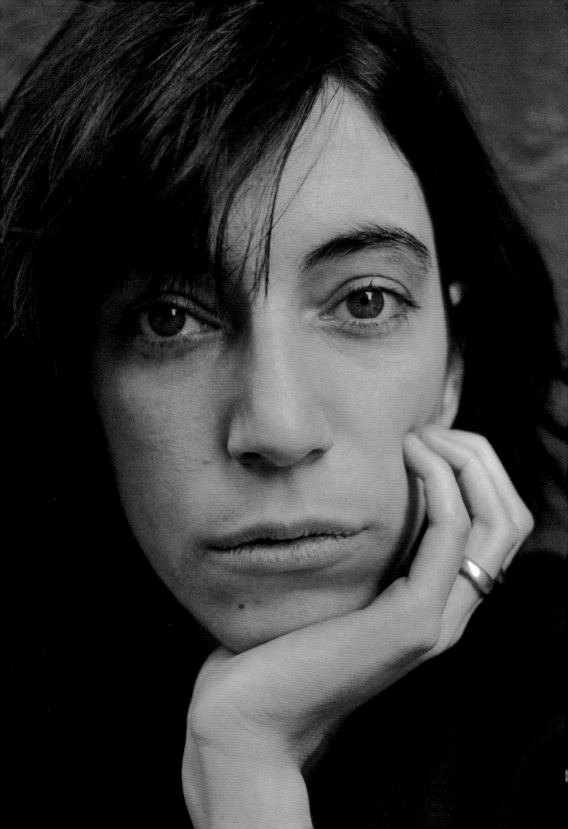

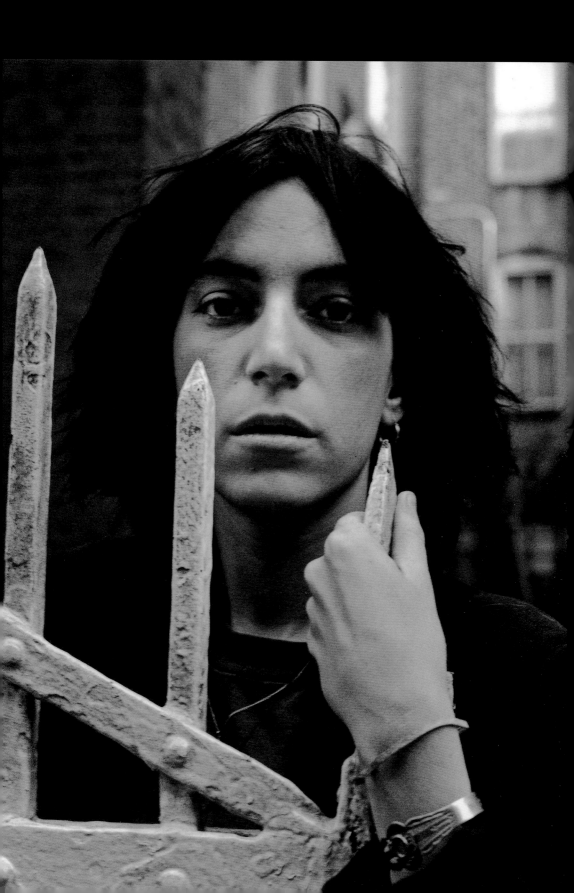

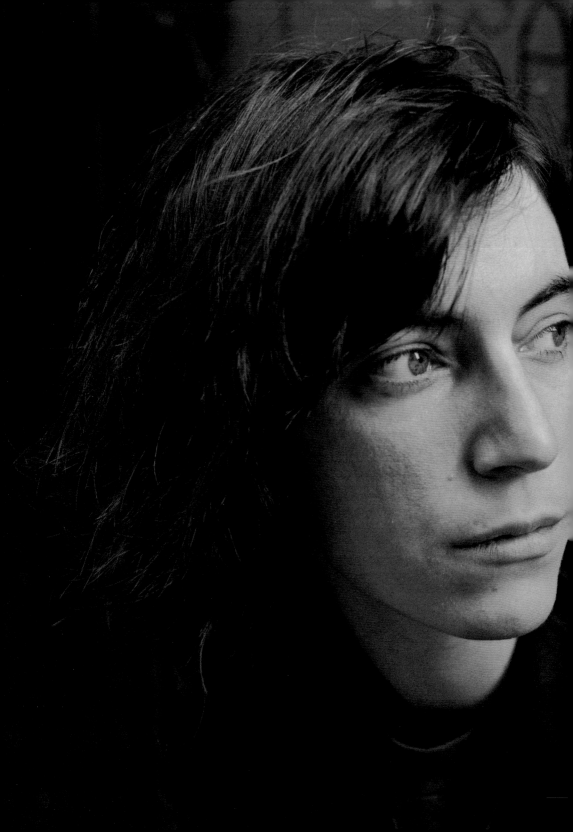

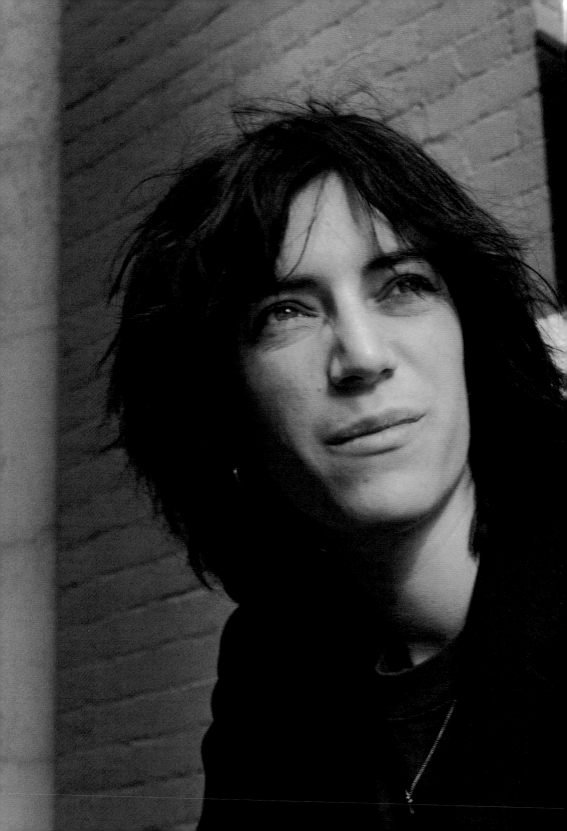

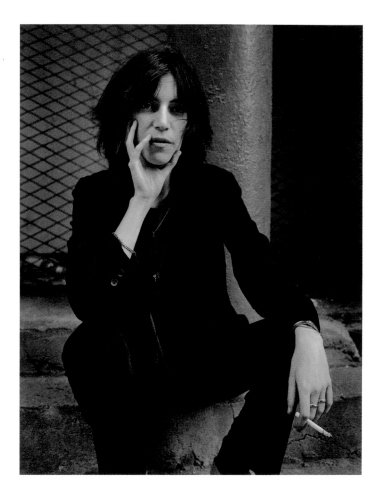

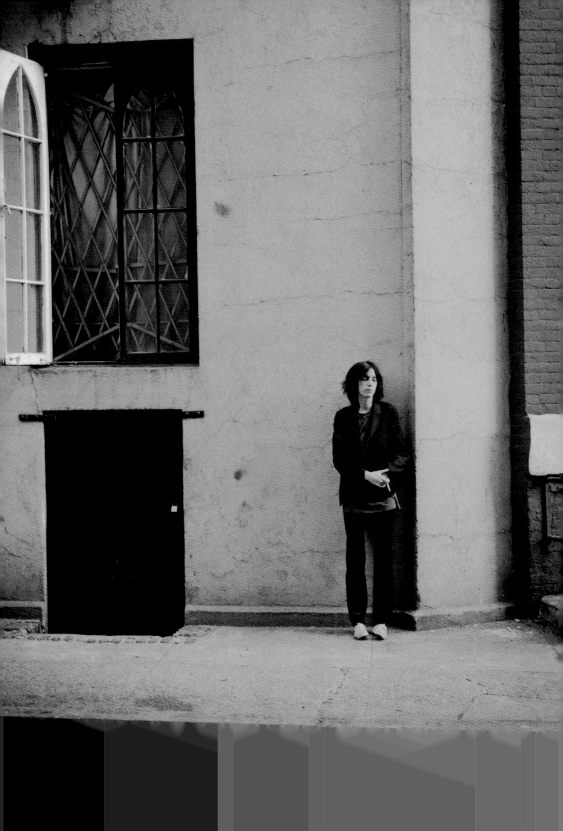

HIDING OUT

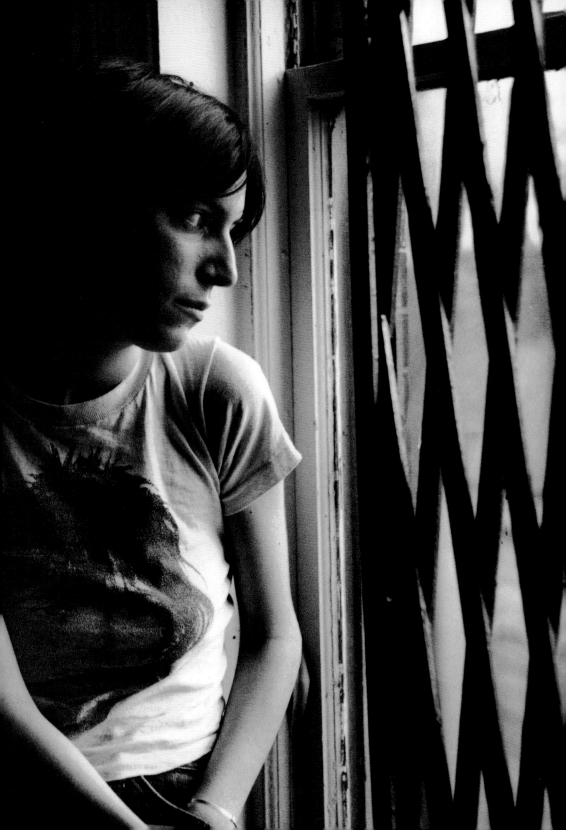

After less than a year on MacDougal Street, Patti left the whole Greenwich Village scene for the East Side. At this point, she was doing more club gigs with her band and, although she was enjoying greater success, she needed space to find out who she was and where she was going.

Working the whole day and into the night, we did our next photo session in Patti's bare-to-the-wall apartment on Eleventh Street. Sunrays from the east came into the near-empty flat. Her hair shorter, she wore a Keith Richards T-shirt and worked the room to reflect her emotions, like Anna Magnani in one of those sixties Italian flicks. Patti played her role passionately as the subject in a rather sparse environment. At moments she was just having fun and laughing, and then she would turn quite intense and serious. The feeling was very different from our last photo shoot. Patti seemed preoccupied. You could tell she was in a period of transition.

She was working on her seminal album, *Horses*, with the great Robert Mapplethorpe cover. Just before the release of that record, I had the extraordinary privilege of witnessing an important moment in Patti's evolution as an artist. She and I were driving uptown in my car on a hot New York day. As we headed up Sixth Avenue to get something cold to drink—a pineapple smoothie or something—she was going over the song "Land," which hadn't been recorded yet. As she reworked different parts in her mind, she sang her ideas out loud, refining the opening crescendo:

> *" . . . horses, horses, Horses, HORSES, do*
> *you know how to pony, like Boney Maroni . . . "*

I felt so lucky to have been there, witnessing a part of that song being born. Released a year later, in 1975, *Horses* was very well-received and brought Patti national attention. Who was this female rocker? It was a breakthrough album by a new artist whose music was different than anything else out there. I listened to *Horses* over and over again, stunned by the range of her musical talent. Here was this slender woman with a voice that could have come out of a street singer from South Philadelphia or from a star on Broadway. The inflections in her voice called to mind showtunes or a singer belting it out a capella with a group on a stoop in the Bronx.

Patti had been raised on a very well-rounded diet of all kinds of music and she brought it all together in her own way. Before Dylan and the Stones grabbed her attention, she was into soul and Motown like the Temptations and Smokey Robinson and the Miracles. Growing up near Philadelphia, she heard the old rock-and-roll sounds of the Paragons, the Jesters, and the kind of music that legendary Philadelphia DJ Jerry Blavat broadcast from the Camden City Hall. Listening to Patti's songs, I can sometimes hear Blavat chanting, "Coming out to ya from the big tick-tock on the tower-power clock. This is the geeter with the heater, the boss with the hot sauce, calling all you yon teenagers," before playing some great old song like "Pledging My Love" by Johnny Ace.

For me, Patti's unique style sometimes echoes those great stories she told when we were young and still in school. Roaming the streets in Philadelphia, she described faraway places and her desire to be a torch singer nestled up to a microphone in some smoky cabaret in France or Germany like Edith Piaf or Marlene Dietrich. As an emerging artist, her distinctive vocal ability helped her gain increasing public appeal, and certainly added to her success.

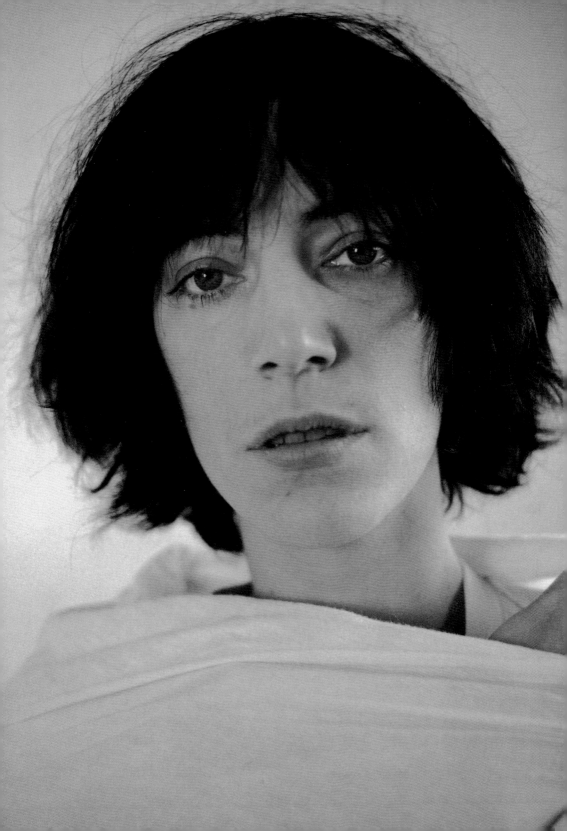

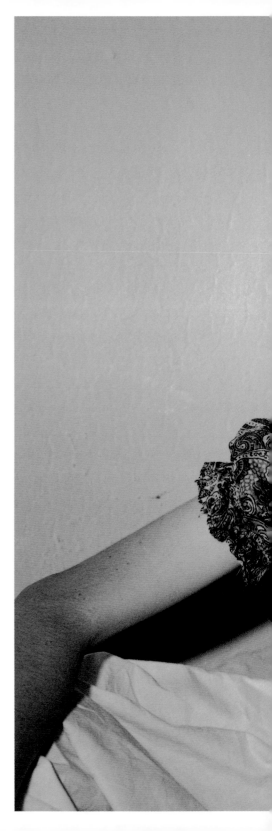

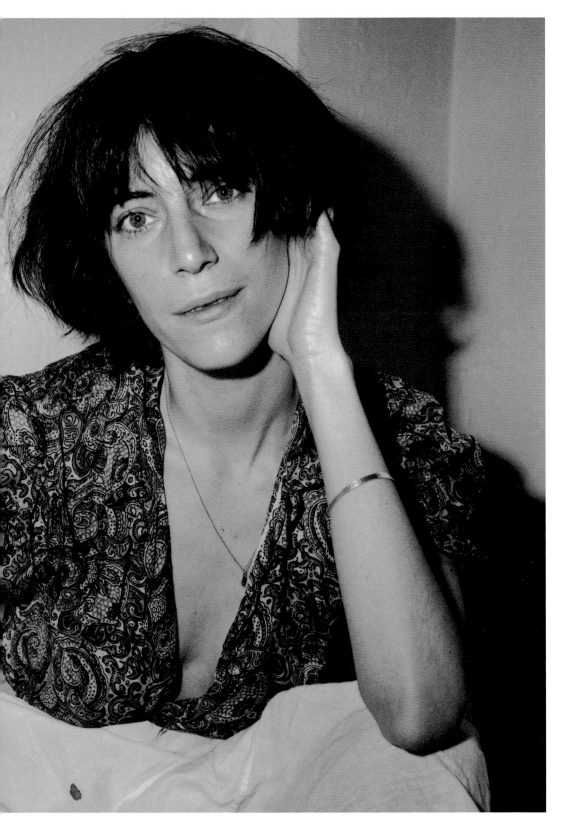

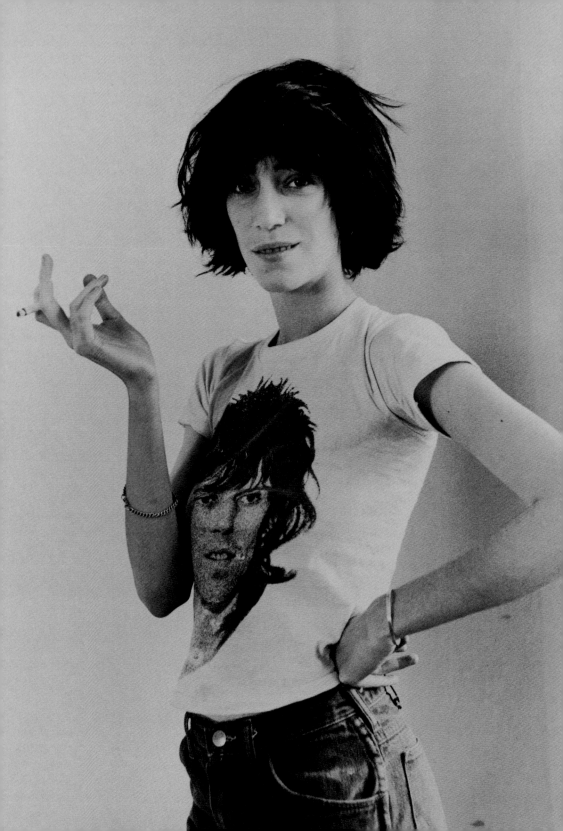

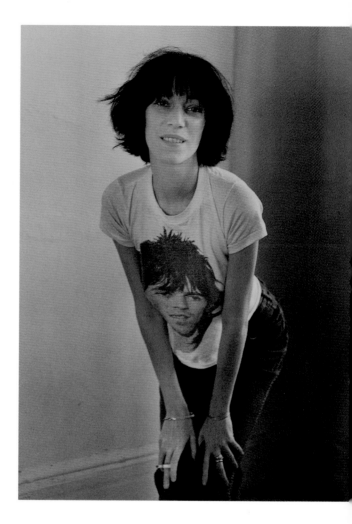

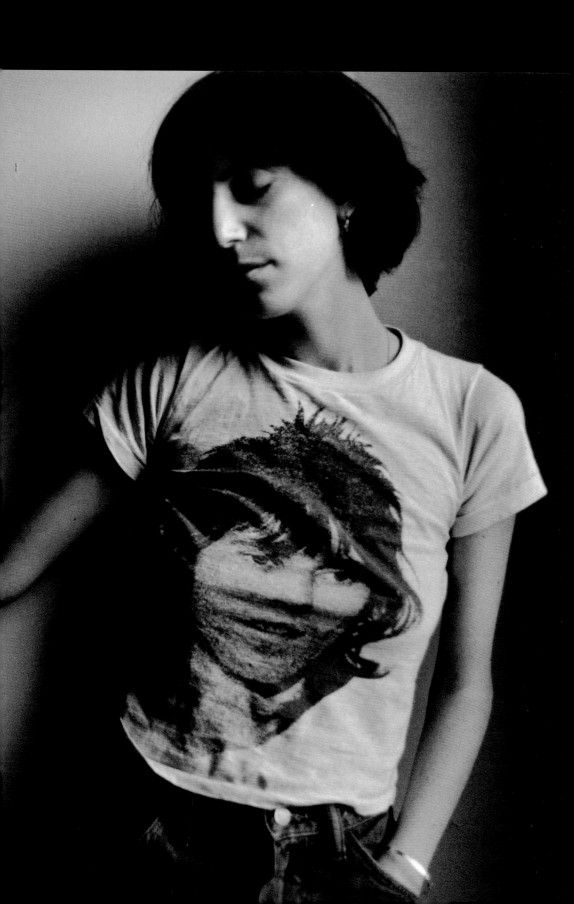

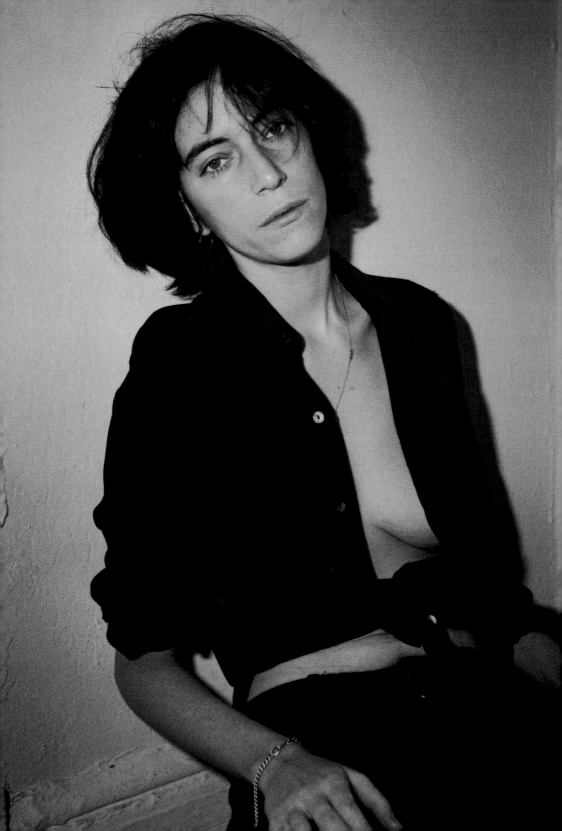

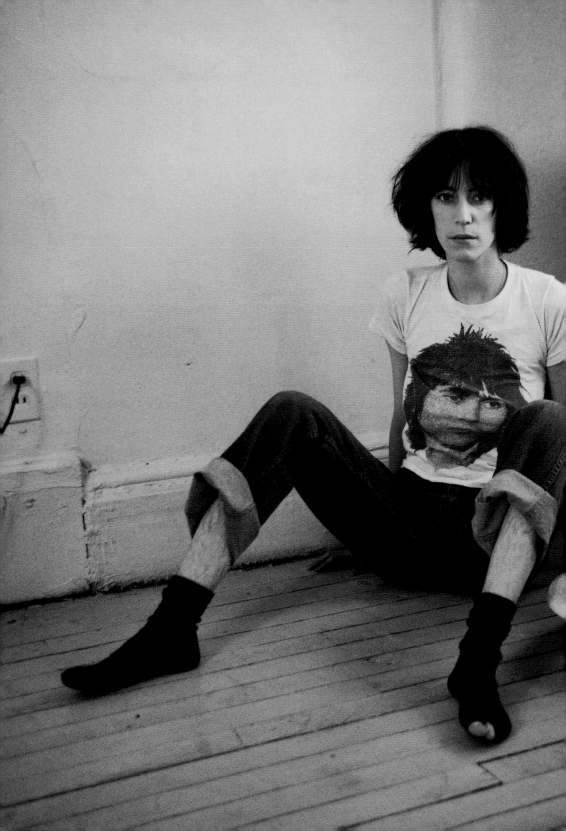

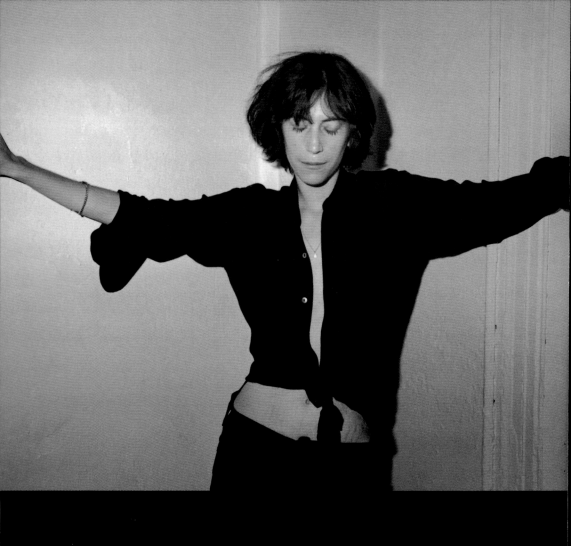

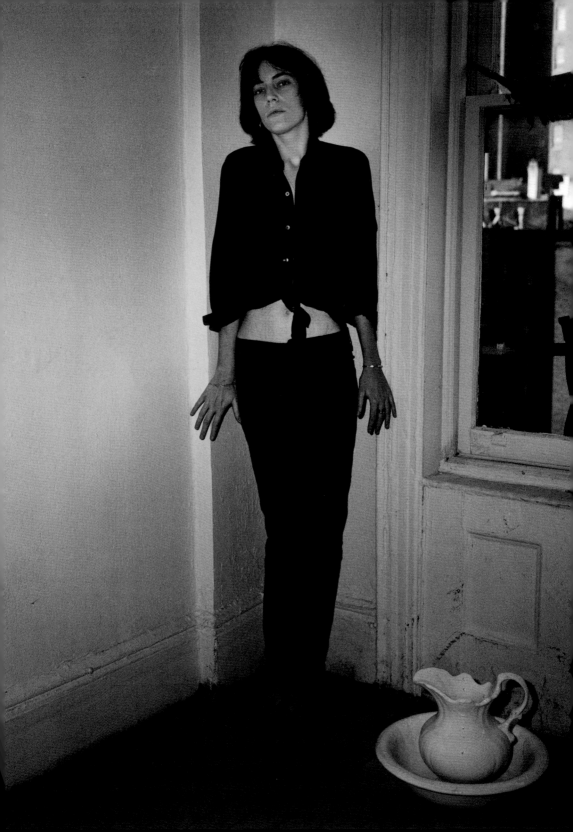

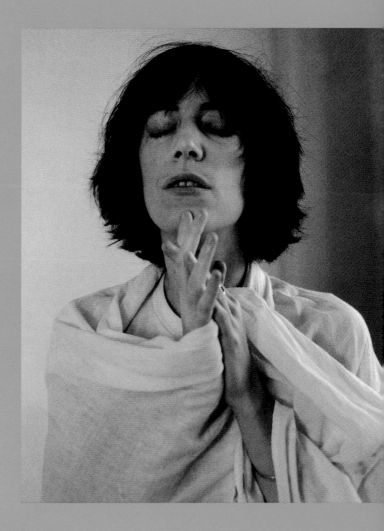

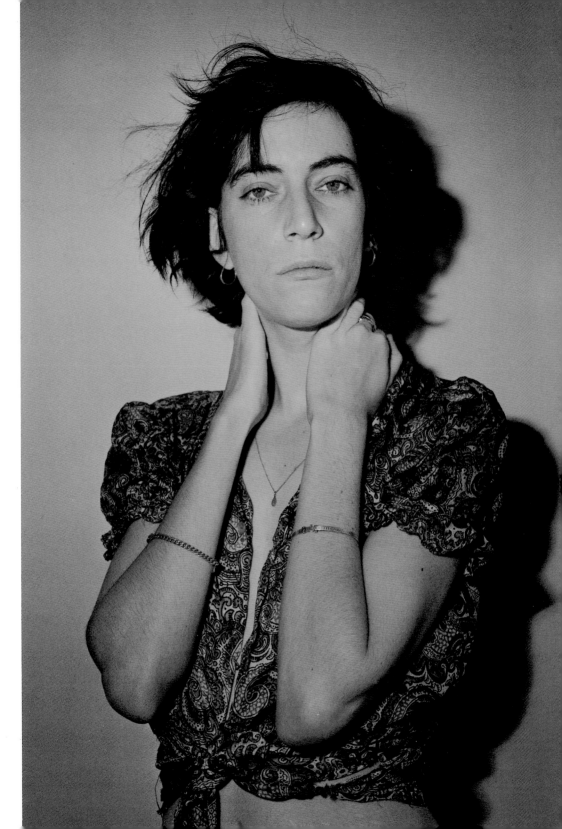

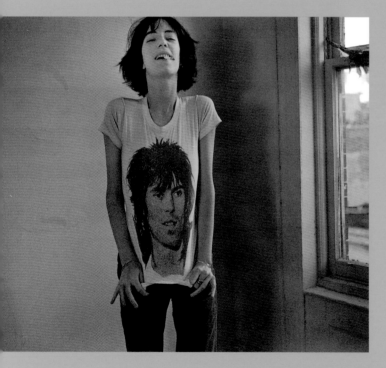

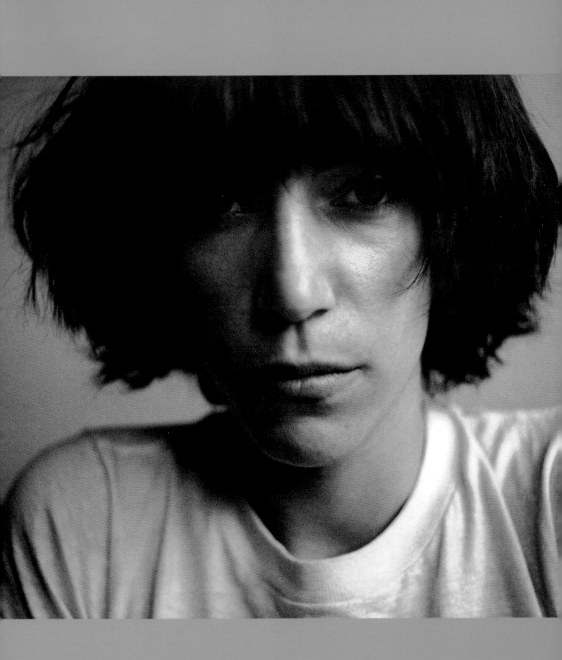

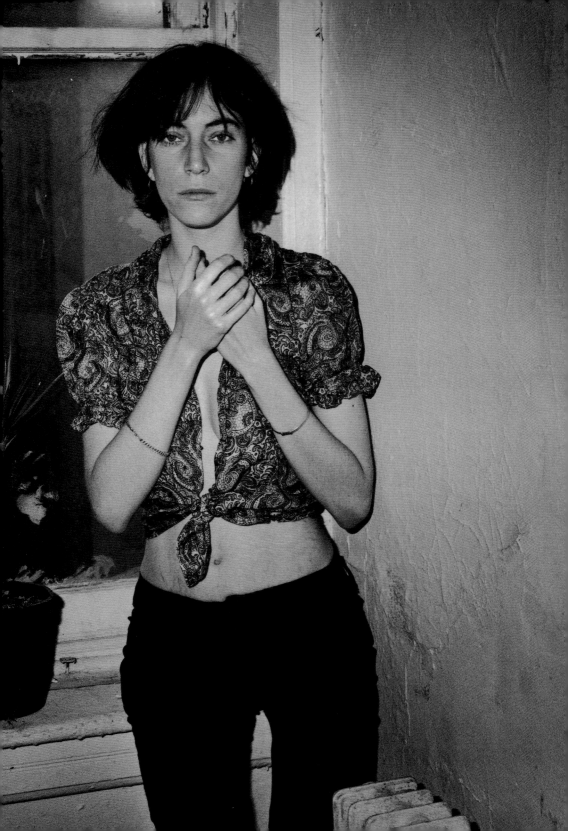

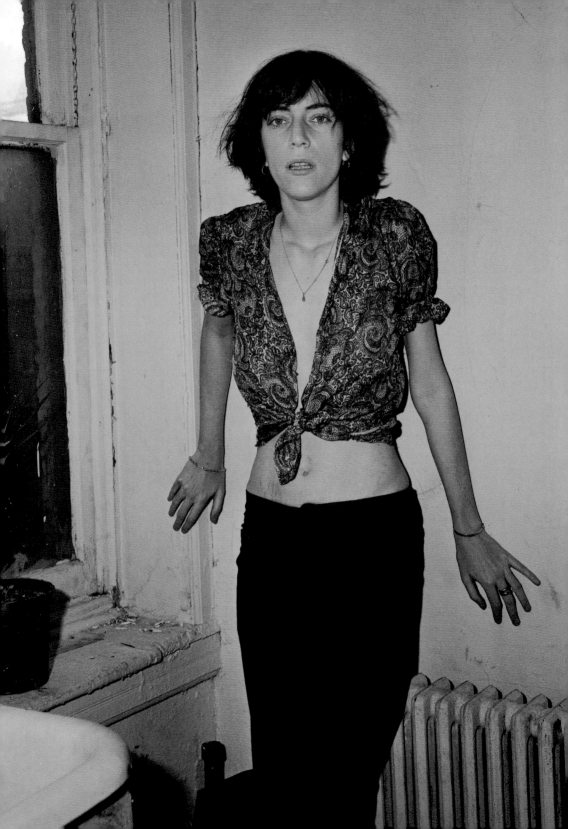

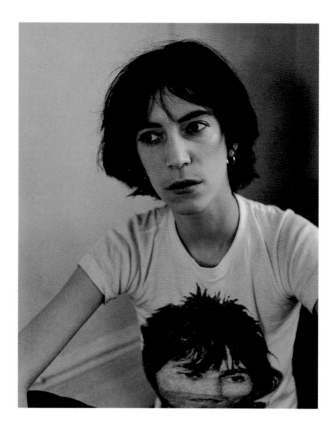

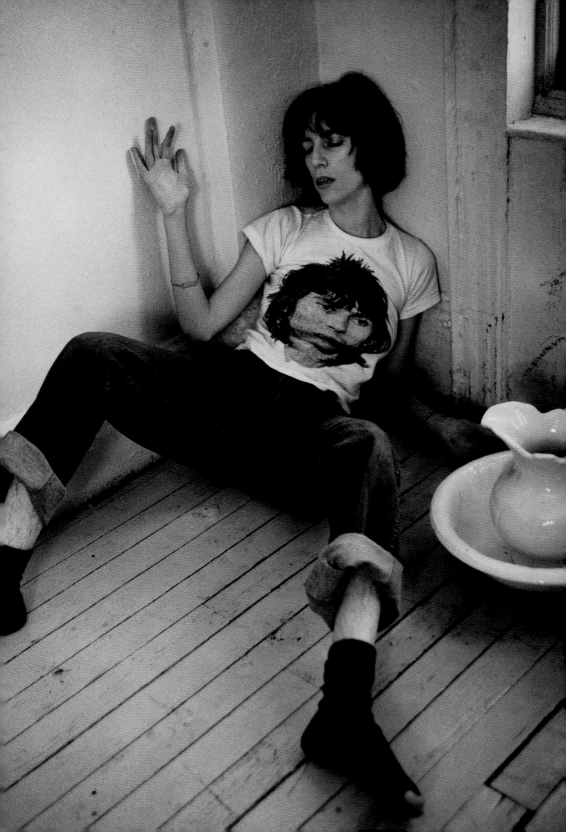

RADIO
DAYS

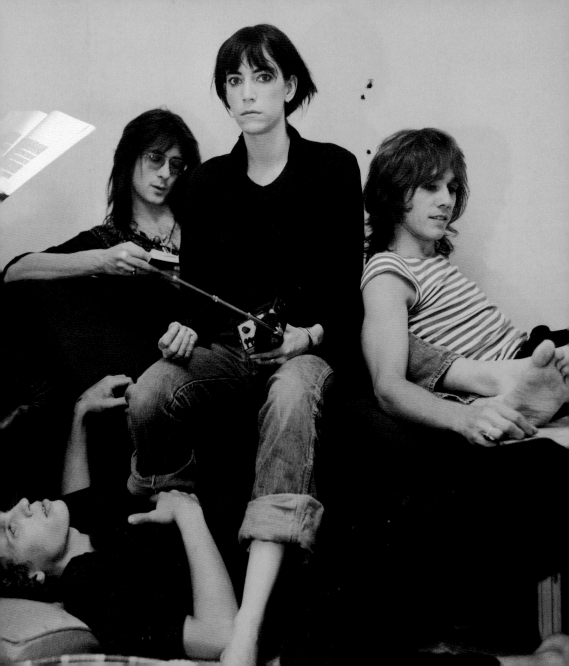

In 1976, a year after the release of *Horses*, Patti invited me to come to New York to take some shots of her and the band. She was working on her second album, *Radio Ethiopia*, the cover of which was ultimately done by Judy Linn, a wonderful photographer and good friend of Patti's. That was fine with me because I knew Judy and was happy for her. Besides, I got some of my best photographs during this incredible session.

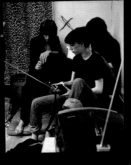

The original Patti Smith Group included the great Lenny Kaye on guitar and Jay Dee Daugherty on drums, both of whom are still in the band. Patti is the commander of course, but Lenny has always been instrumental in holding things together, the peacemaker of the group. He continues to be a great artist in his own right as a musician, rock-and-roll historian, writer, and record producer. Jay Dee always has a boyish grin on his face and, man, what a powerful drummer. He can really kick the skins. On keyboards was classically trained Richard "DNV" Sohl, a beautiful guy—outrageous, gentle, and vulnerable all at the same time. And bassist/guitarist Ivan Kral was a handsome Czechoslovakian. To Patti, it was important that her band be great musicians who worked harmoniously as kindred spirits, but it didn't hurt if they were attractive onstage as well.

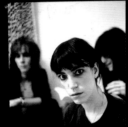

We did the photo shoot in a midtown Manhattan rehearsal studio where Patti and the band were working on *Radio Ethiopia*. Amplifiers, guitars, drums, incense, posters, Indian and Moroccan baskets, objets d'art, and an old portable television were strewn all around the place. I took some photographs of Patti perched on a chaise lounge with a guitar strapped around her neck. The TV was on with no sound, and reruns of the old black-and-white series, *The Avengers*, happened to be on. Later when I went into the darkroom, I was amazed to see John Steed and Emma Peel clearly in the frame. It was such a random occurrence we left them in.

The Avengers actually fit the scenario. After all, *Radio Ethiopia* was a mission for Patti. She and her band were calling out across the world, trying to get their message heard through global radio. We incorporated walkie-talkies and telephones into some of the shots to capture the essence of the project, and to show Patti as a politically active artist. She has never been afraid to voice her opinions about oppression and social inequity and to ask, "Hey, what can we do about this?" Years later she wrote a song called "People Have the Power," a call to recognize that we don't have to stand back idly and accept injustice; we can take action through artistic expression. *Radio Ethiopia* was an open microphone to and from the planet.

Wearing a Rastafarian shirt for the shoot that day, Patti clearly found the spirit of reggae to be a source of inspiration in her music. She brought that great, heartfelt beat to the song "Ain't It Strange" and incorporated sounds of artists like Bob Marley, Toots and the Maytals, U-Roy, and Jimmy Cliff into the *Radio Ethiopia* album. In fact, reggae—as well as all other kinds of music—was blazing from the record player as Patti, the band, and I all moved around from room to room taking photos.

Fortunately, there were five people so I didn't have the compositional problem of dealing with an even number of subjects. But I wanted to capture the feeling of the Patti Smith Group as a tightly knit family without it looking contrived. Thankfully, this was a great group to work with, and they were extremely cooperative in terms of me suggesting poses.

After several hours, the session started to get wild. Every time we set up a shot, intensity would build until the shutter clicked. Periods of boredom were followed by bursts of creativity. Consider a bunch of people doing this all day long in a couple of small, hot rooms, and you can get a sense of how crazy it got. The *Radio Ethiopia* photo session was an art-infused steam bath.

We shot until the film was spent, the ideas were spent, and we were spent. Exhausted, I crawled into my car and drove back to New Jersey. When I processed the film and saw the blur of the day come out in these images, I was so pleased. This had been one of those rare opportunities to get very close with the musicians and work together to realize a specific concept. I'd captured a special time, a remarkable moment in the ascent of Patti and her band.

Patti had created a complete work of art with this album. *Radio Ethiopia* was ahead of its time. Looking back at all the different styles she used like oils on a palette, each song could have been framed and hung in a gallery. When you consider Patti's rich portfolio of songs, many of the richest are from *Radio Ethiopia*.

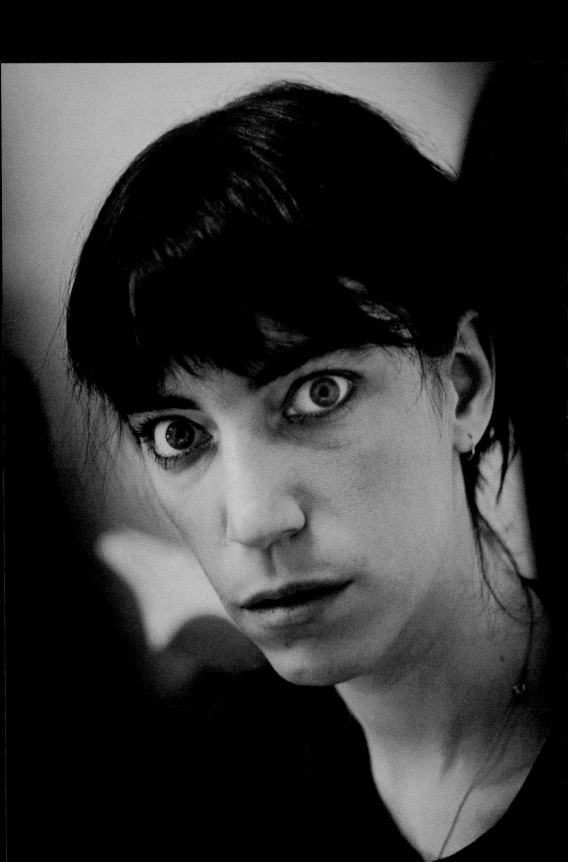

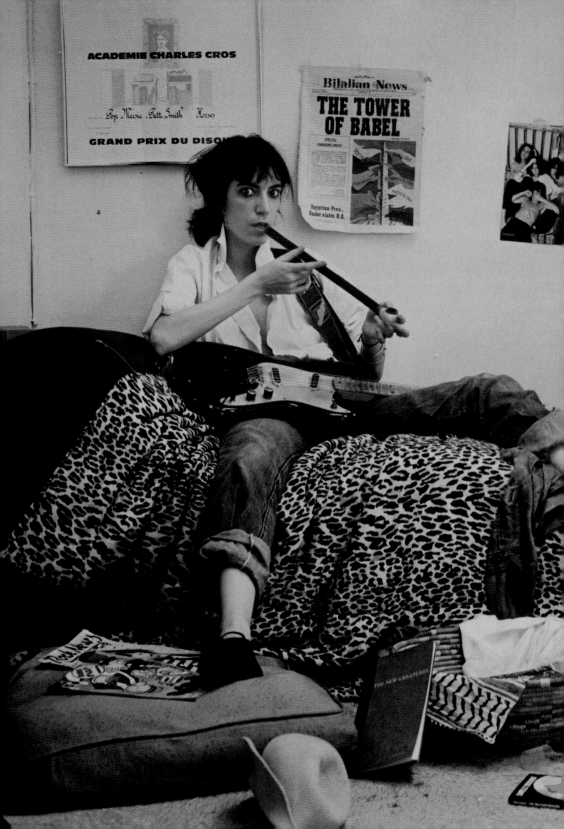

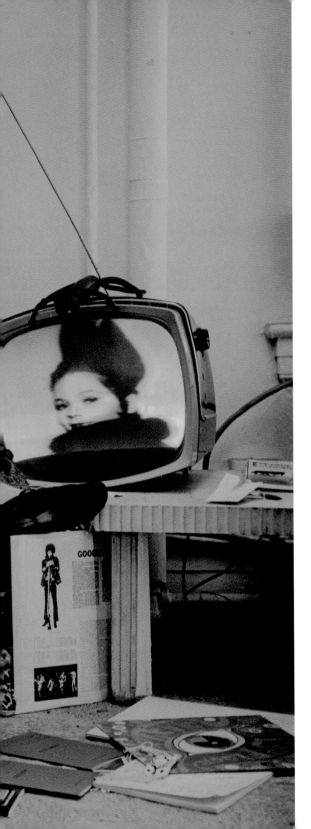

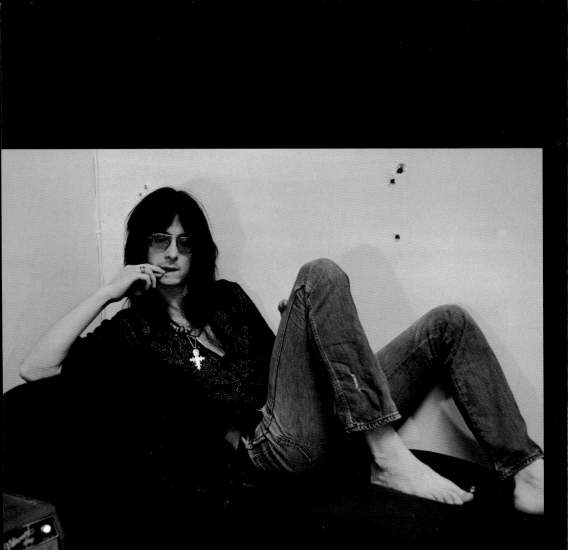

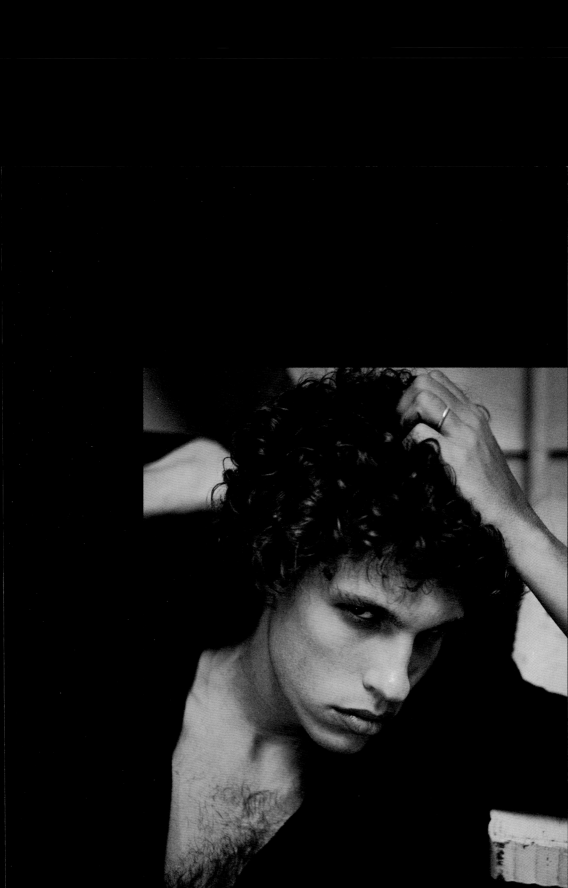

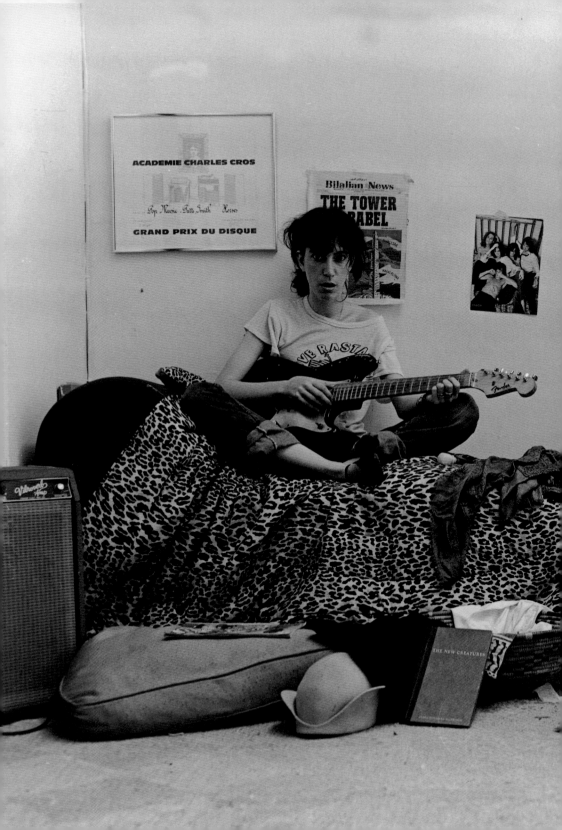

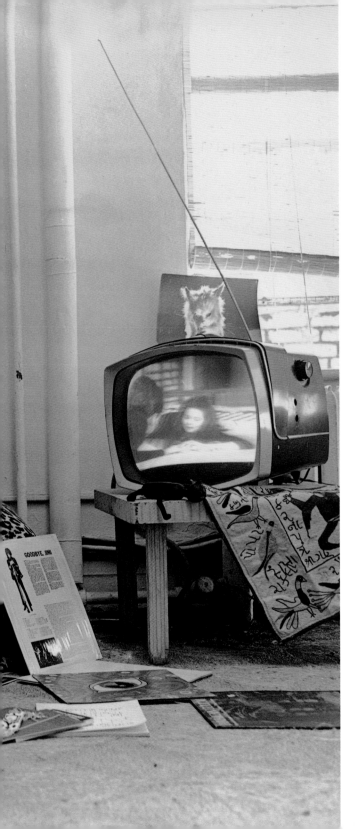

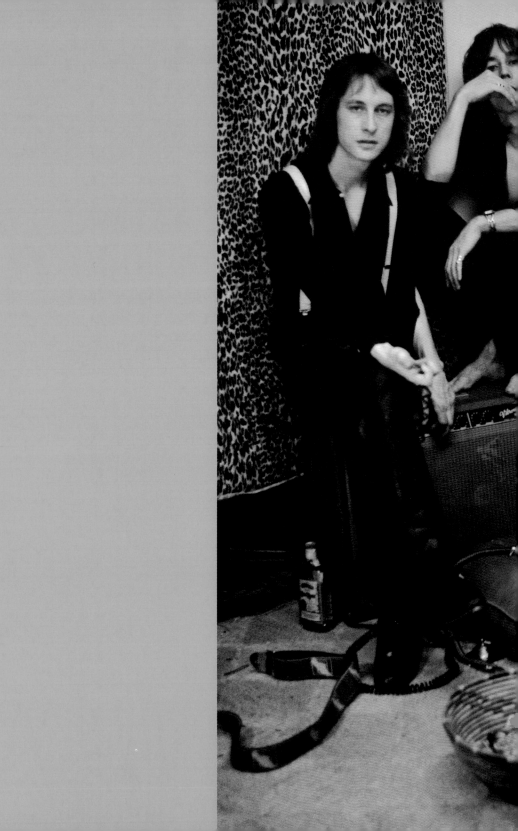

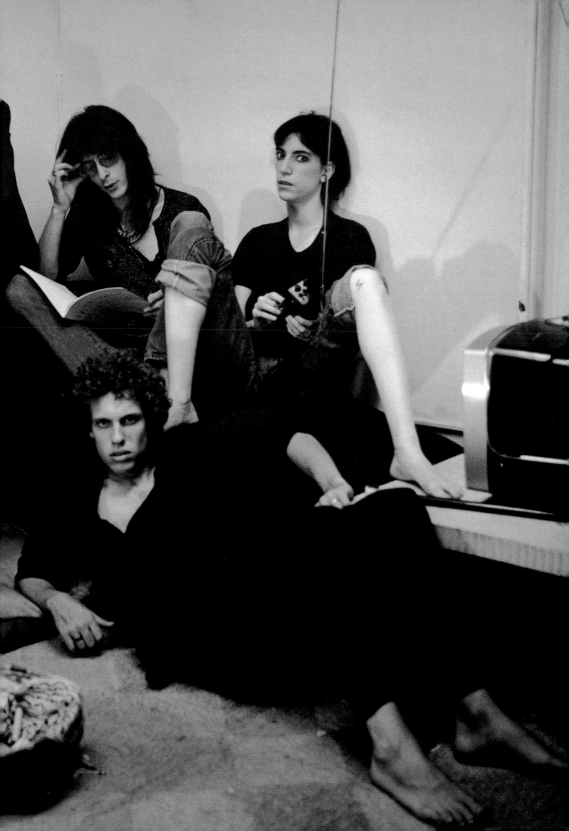

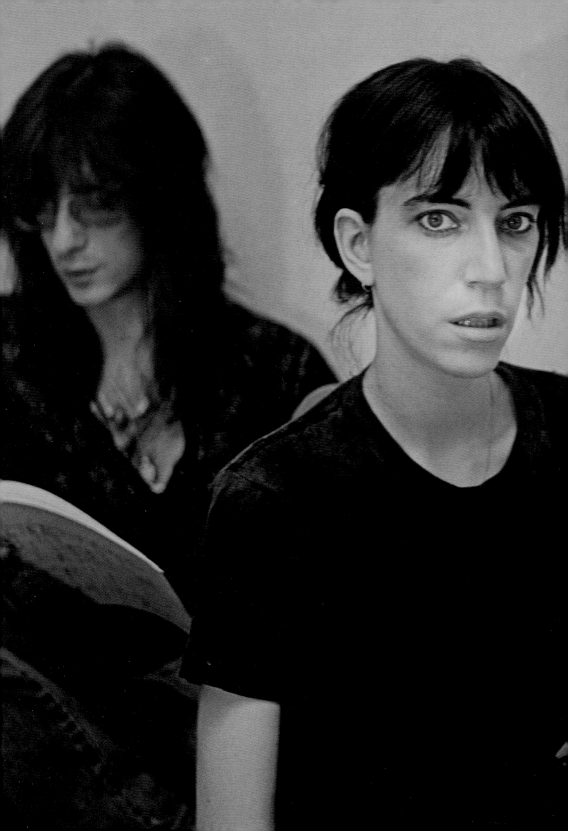

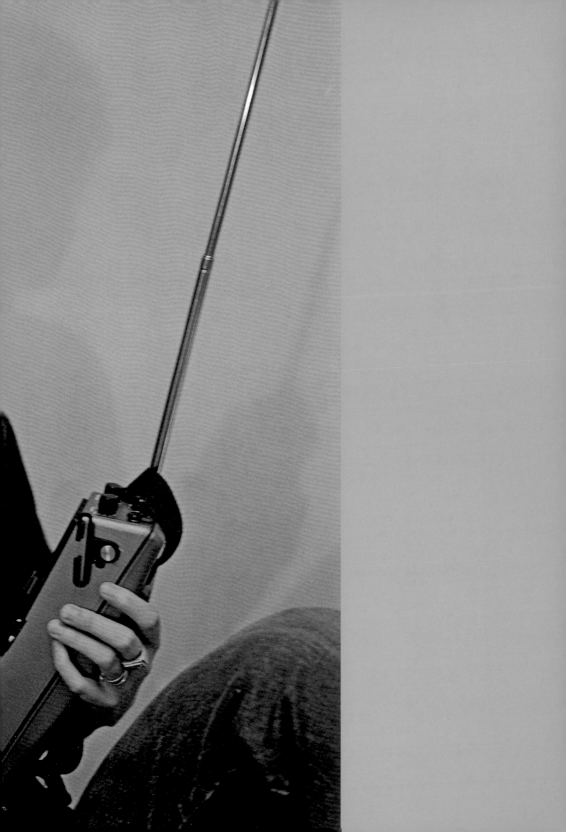

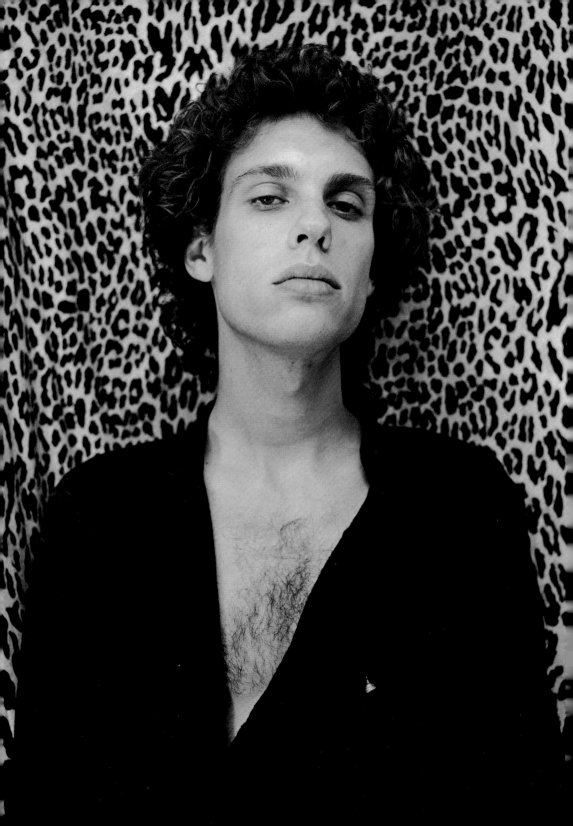

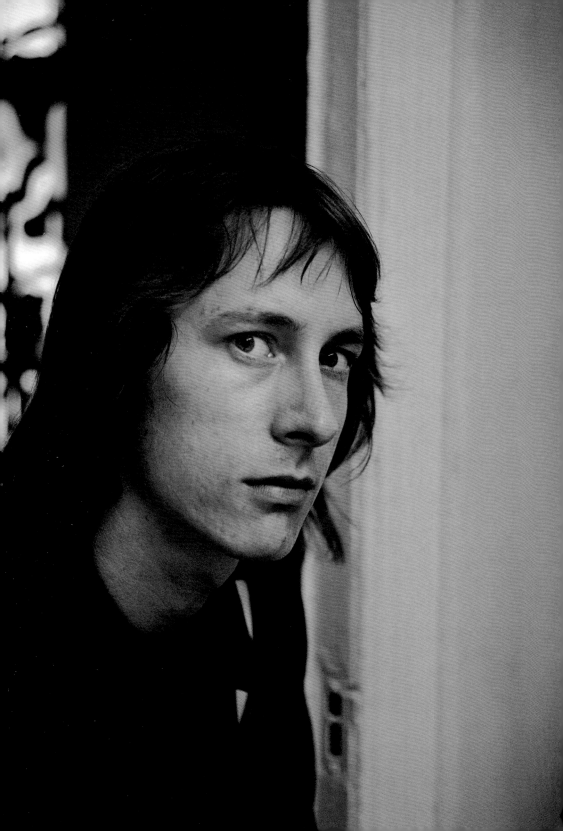

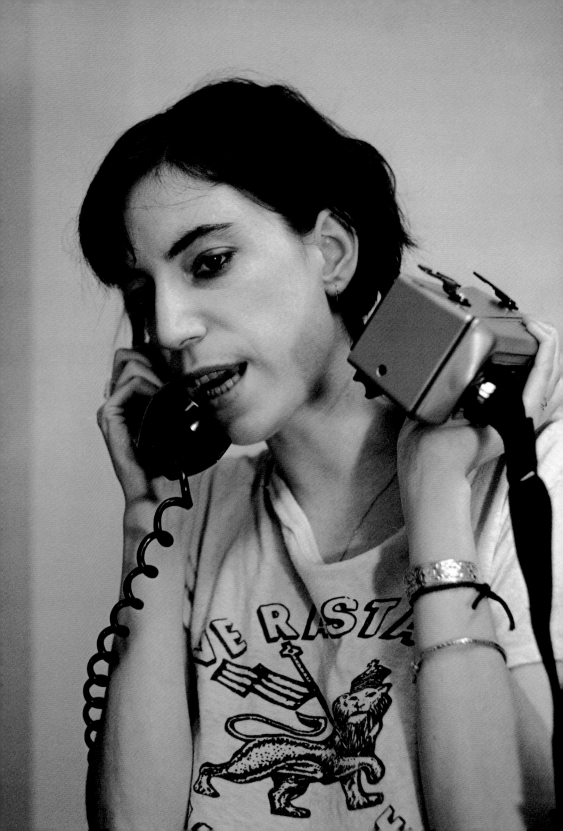

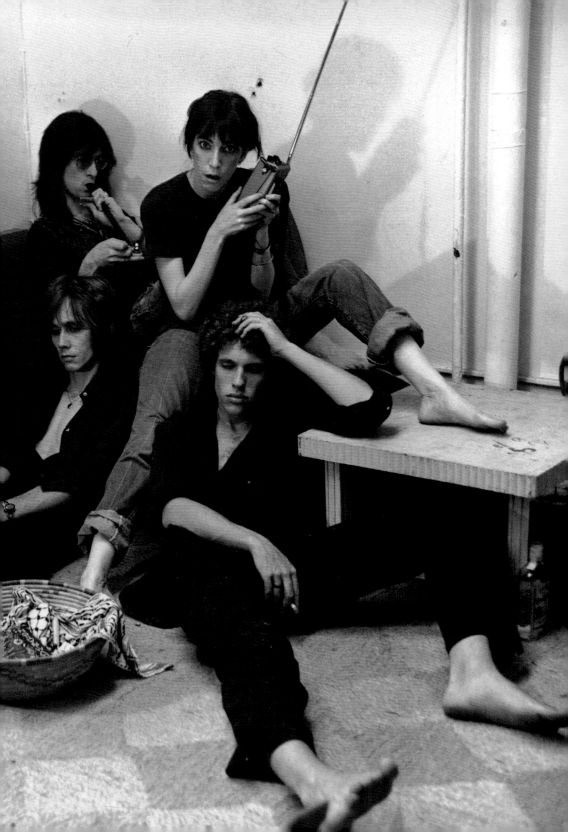

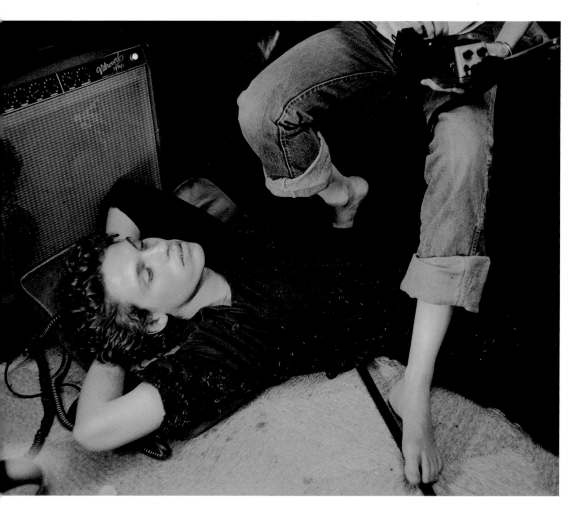

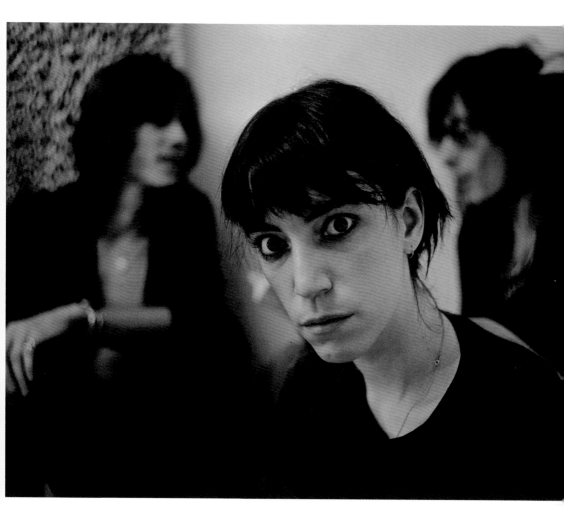

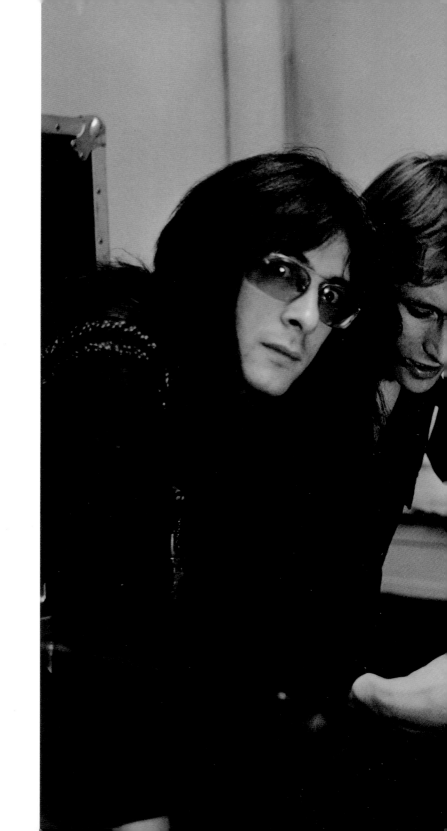

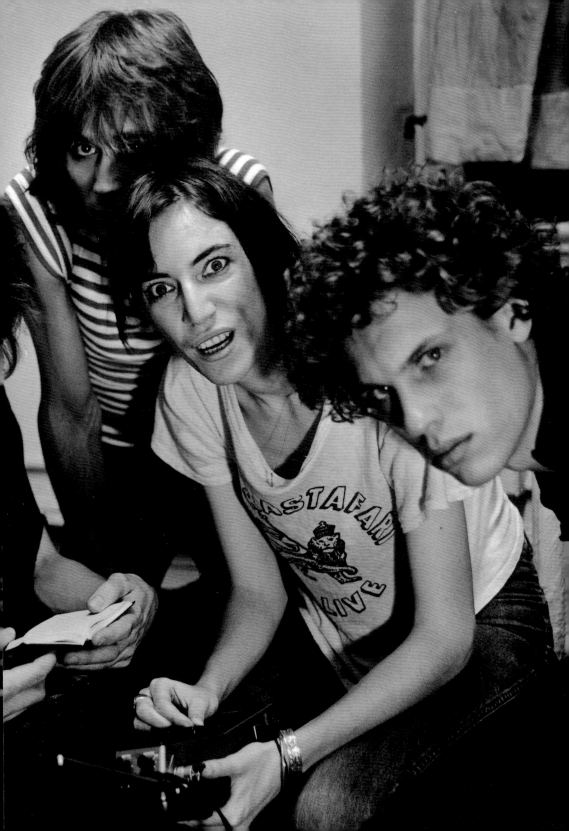

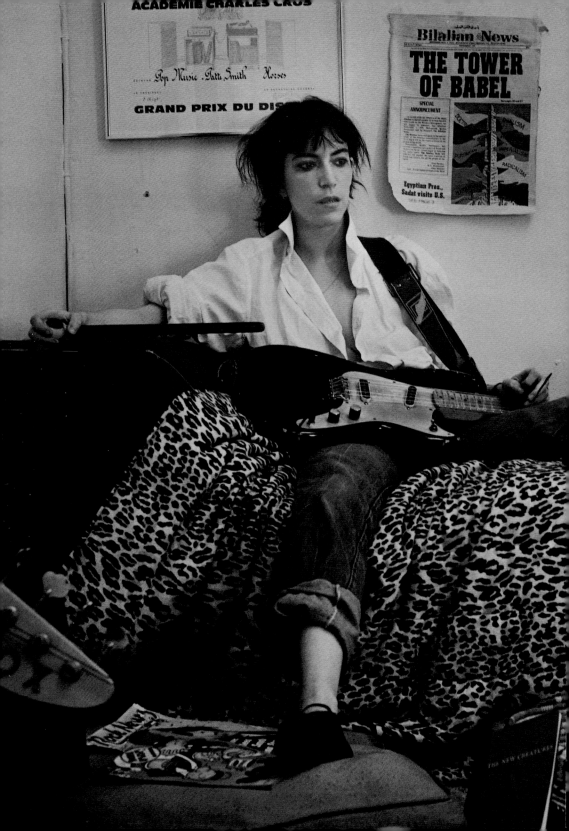

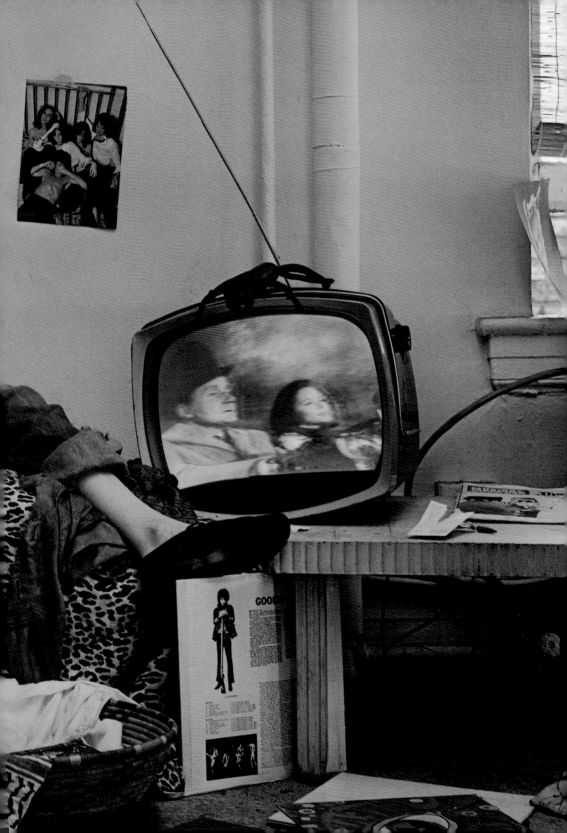

BRINGING IT BACK HOME

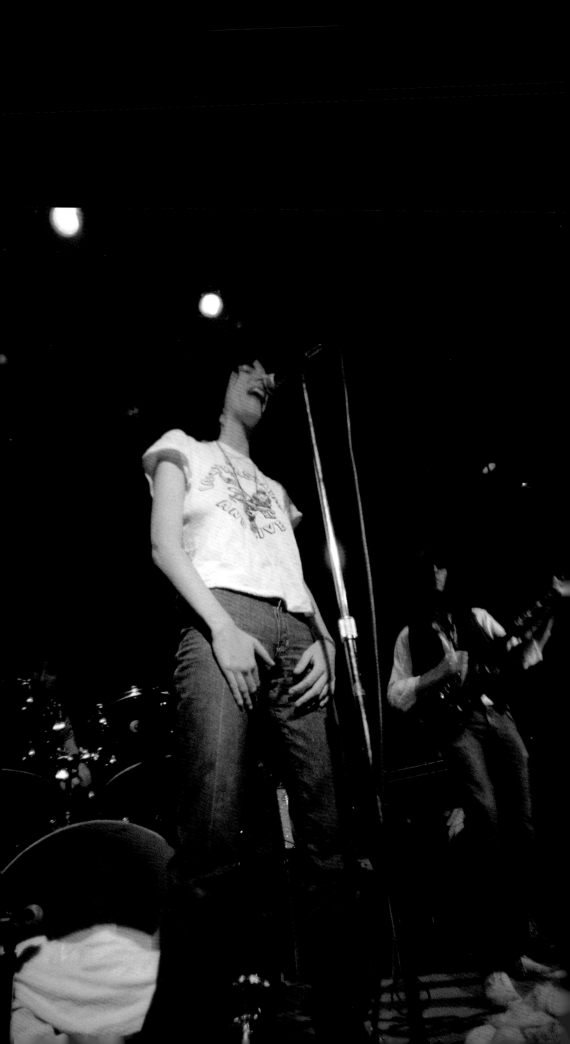

By the mid-1970s, work and family commitments prevented me from making weekend drives up to Manhattan as much as I would have liked. But if Patti and her band were anywhere near Philadelphia, I was there. Her family was extremely supportive and came out to see her as well, especially her mother, who was the president of the Patti Smith Fan Club. For many years until her passing, Beverly Smith would often be in the audience, and Patti always took a moment to say, "Hi, Mommy," from the stage.

Concerts in Philadelphia were a sort of homecoming because Patti had a huge fan base there. Besides, these were our old stomping grounds, the city we knew so well and where we saw our first live concert together. Seeing her in Philly was very special for me.

Patti's shows were always great, whether in smaller places like the Main Point, the Bijou Cafe, and the Tower Theater, or large outdoor venues such as Penn's Landing. At the Main Point coffeehouse in Bryn Mawr, I stood across the room with a telephoto lens taking close-ups of Patti onstage. The combination of a powerful lens, fast film, and an intense white spotlight caused a strange bleed effect on the film. It literally showed Patti in a different light.

At the Bijou Cafe, which used to be on Lombard Street in downtown Philly, I was right up front for a show and got some photos of Patti wearing that Rastafarian T-shirt from our *Radio Ethiopia* shoot. Jay Dee Daugherty was so fast and intense on drums that night he came out blurred in the pictures. Watching Patti interact with the musicians, especially Lenny, it was impossible not to feel the camaraderie between them all.

At a show at the Tower Theater in Upper Darby, Pennsylvania, I checked out the backstage scene before Patti went on. She looked fashionable wearing a wide-brimmed hat, and hanging out with her was a distinctive fellow with a scarf tied around his neck who turned out to be none other than J. Paul Getty III—a huge fan of Patti's art.

One of Patti's most memorable concerts for me took place in 1979 at historic Penn's Landing in Philadelphia, along the Delaware River. A local radio station, WIOQ, sponsored the large outdoor event and Patti was the featured act. Two local disc jockeys, Pierre Robert and Ed Sciaky, were there. The late, great Ed Sciaky loved Patti's artwork and promoted her heavily in the Philadelphia area. Over the years, I remember seeing Ed at every one of Patti's appearances. You never knew what Patti would do onstage at any given moment, and I suppose Ed didn't want to miss anything.

When Patti asked me to take some photographs at this concert, I was delighted. Always the jokester—who appreciated the quick wit of Johnny Carson—she liked to start shows with a one-liner to loosen up the audience. For the Philly crowd that day, she got things going with, "Sorry I'm late, but I had to go get a cheesesteak."

Then those beautiful hands took the mic. Her elongated, delicate fingers were almost as expressive as her eyes. As the show progressed, Patti's entire body got into the music: dancing, jumping, and playing the guitar or flute. Her whole being filled the stage.

The Penn's Landing concert was the first time I worked onstage during one of Patti's performances.

I had never experienced anything like it before. With the band playing full-force and the speakers pumping on an elevated plywood platform, everything was vibrating. The whole world was pulsating with music, and Patti was having the time of her life. She was back home, having a huge party with family and thousands of friends around her. You could feel the joy and love of this incredible day just by looking at the eyes of Patti's brother, Todd. Part of the band's road production team, Todd left this world much too early in life. But on that day he was celebrating and thrilled to be there, sharing his sister's triumph.

<p style="text-align:center">* * *</p>

The Penn's Landing concert in 1979 was the culmination of what I consider a seminal decade in the evolution of Patti Smith. I've taken a lot of shots of her since then, but this collection of early photographs documents the period when Patti was laying the foundations of the richly complex artist that she would become.

Patti continues to be one of the most prolific and important artists very much alive and working today. I catch her performances and frequently hear about yet another book of poetry she's published. I read notices and reviews of her exhibitions of her drawings and paintings in museums and galleries throughout the world.

And she still has that look in her eye, the hungry, inquisitive look of an artist, continuing to see, continuing to question, continuing to express herself.

In the summer of 2005, just before appearing in a special WXPN concert at Wiggins Park on the Camden waterfront, Patti called me up and asked, "Can you meet me before the concert?"

Over the years, Patti has visited the graves of her heroes buried in France—Arthur Rimbaud, Jean Genet, Charles Baudelaire, Jim Morrison, and others. On this day, her pilgrimage continued in New Jersey. She asked me to take her to Walt Whitman's grave in Harleigh Cemetery. Along with us were Patti's friend, Patti Hudson, and my best friend and significant other, Carol Reed. The gates were locked, so we had to sneak in.

Imagine a group of artists and writers sneaking into a historic old cemetery in New Jersey to see a legendary poet's grave. Patti leaned over to Carol and whispered, "You know, I always have the best adventures with Frank." It felt like we were kids again in Rittenhouse Square.

The four of us spent some time at Walt's final resting place while Patti took a couple Polaroid photographs of the grave and did a few rubbings of the tombstone. When it was time to get to the concert, the ladies were slender enough to shimmy through the nearest opening in the wrought iron fence surrounding us. I, on the other hand, had grown a little since our tree-climbing days, so I had to find a place further down the fence line to get through. Just goes to show that it's easier getting into a cemetery than getting out.

Earlier that same summer, Patti was named by the French Ministry of Culture as a Commandeur dans l'Ordre des Arts et des Lettres for her accomplishments as a poet and artist.

Four decades have passed since Patti burst through that college co-op doorway. I feel grateful that not only did I get to know her, but I've been able to maintain a lifelong friendship with her as well. Because of my friendship with her, I've experienced the honor and privilege of photographing her all these years, documenting the amazing evolution of an important and very special human being—Patti Smith, American Artist.

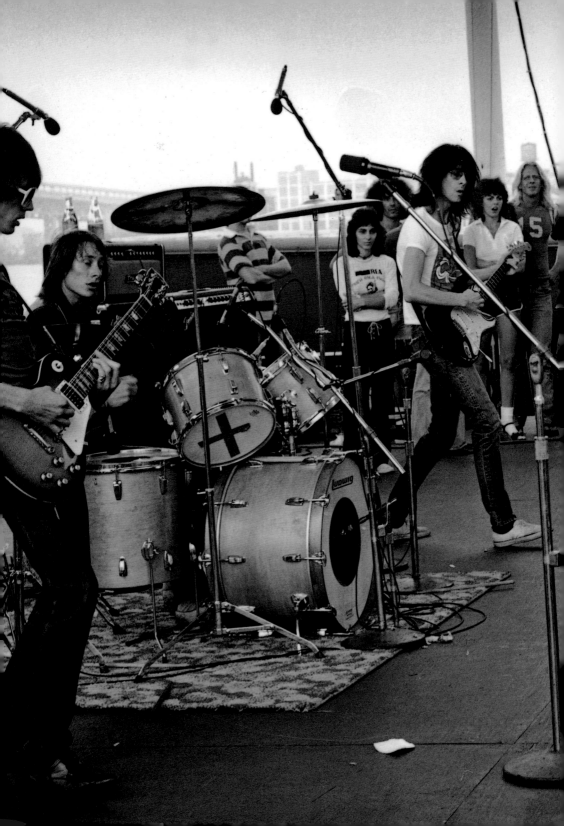

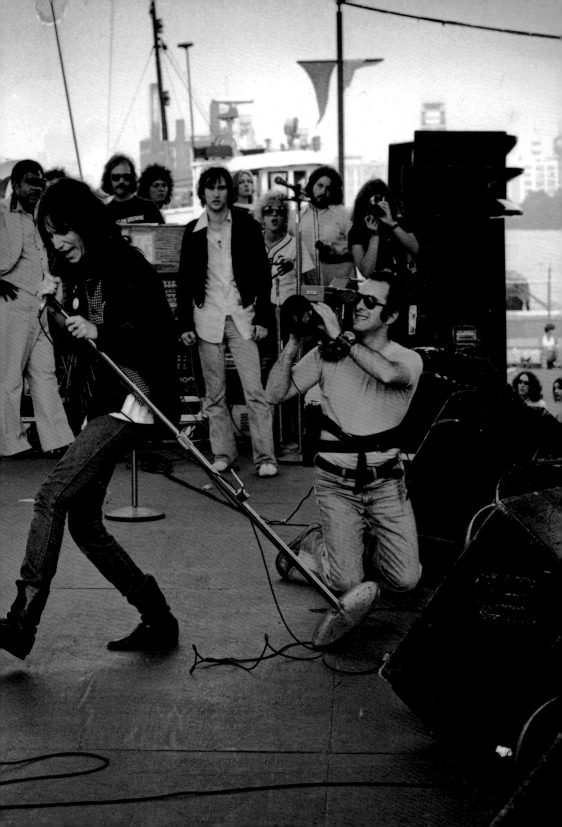

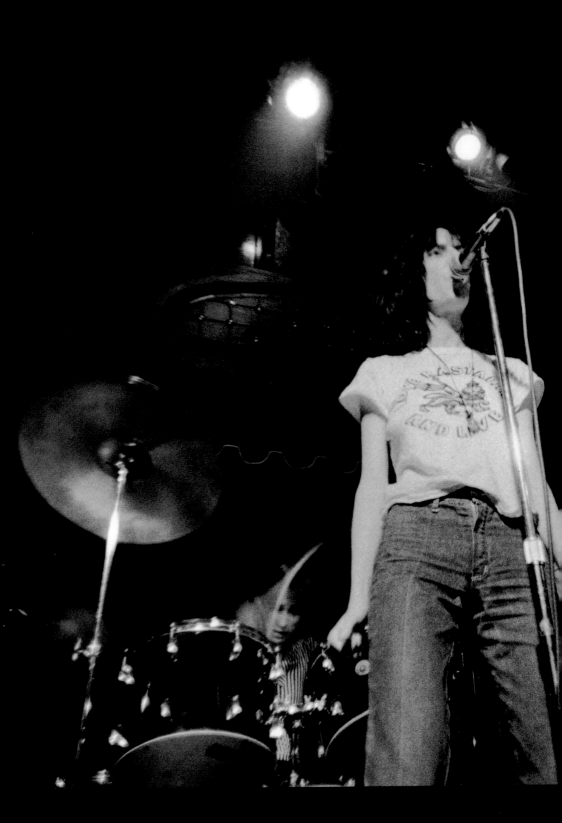

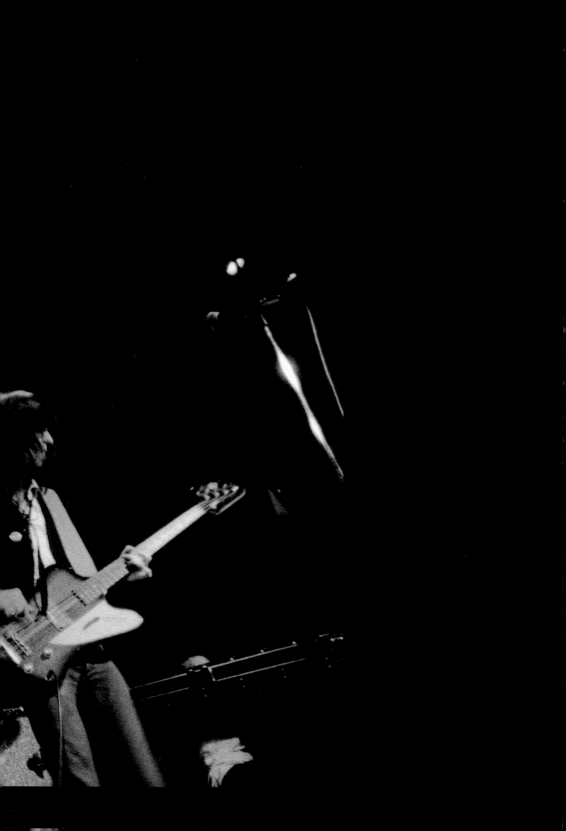

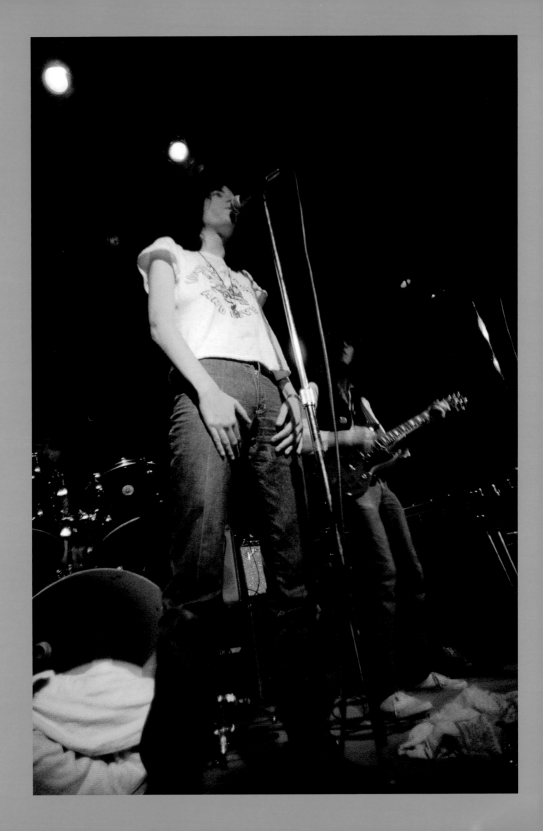

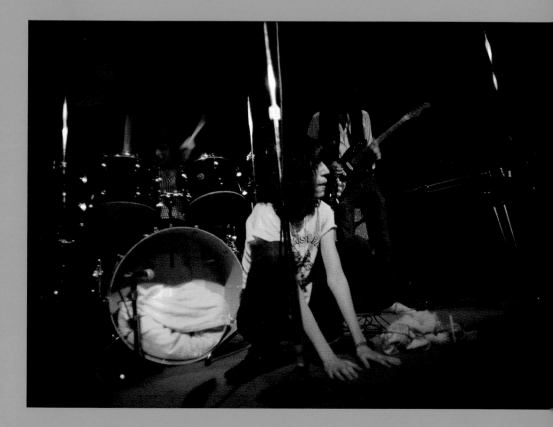

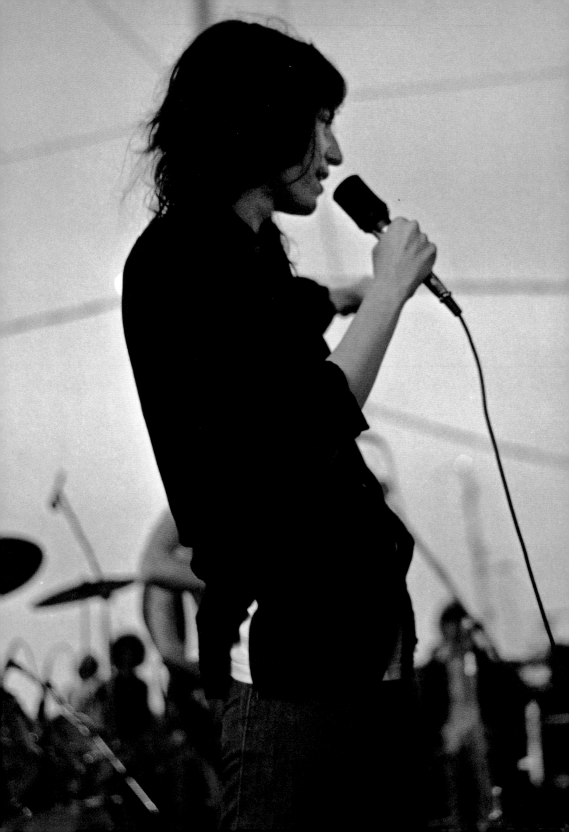

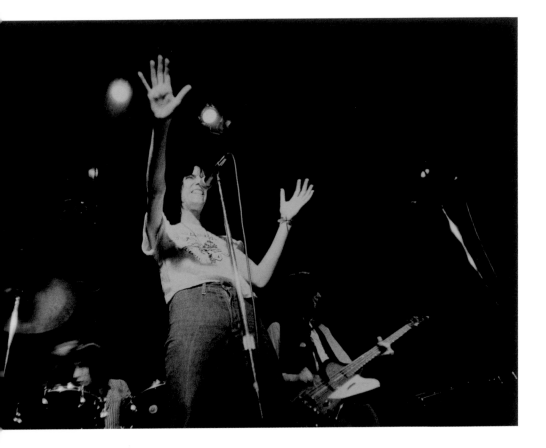

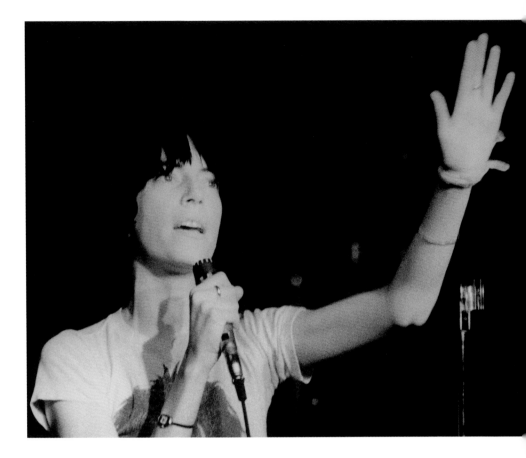

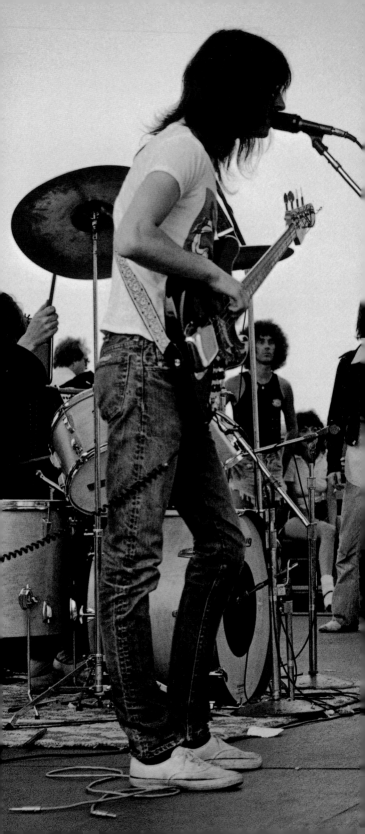

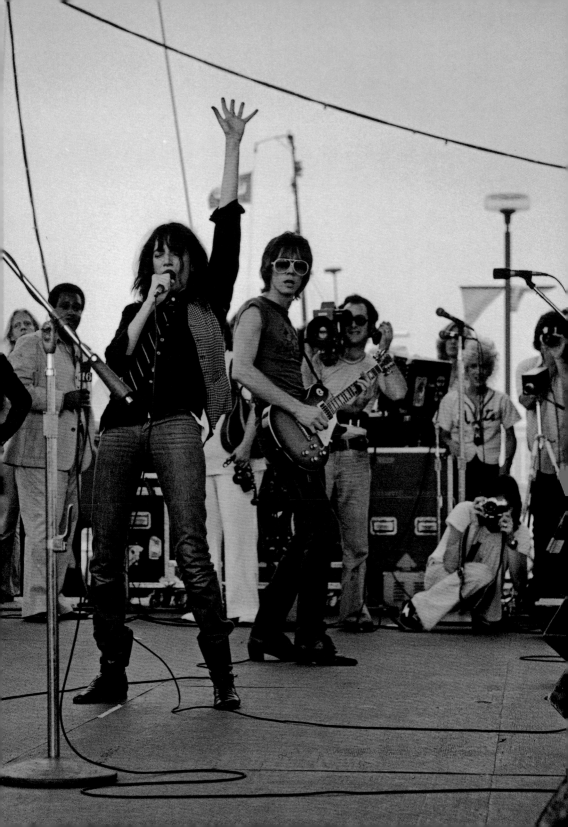

PATTI SMITH

with Lenny Kaye, guitar, and Richard Sohl, piano

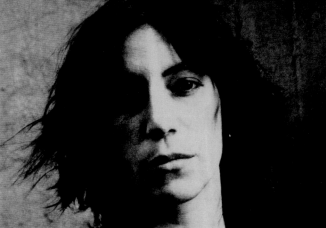

At Max's Kansas City
213 Park Ave. South at 17th St. 777-7870 shows at 9:30 and 11:30
Wed. Aug. 28th-Mon. Sept. 2nd

AFTERWORD

Patti Smith is no stranger to photography. She is a photographer who has been the subject of countless photographers, including modern masters such as Richard Avedon, Robert Mapplethorpe, and Annie Leibovitz. She has written about photography, as a contributor to Mapplethorpe's *Flowers*, *Annie Leibovitz: American Music*, and *Bygone Days: 1907-1957 Photographs by John Penor and Family*, among others. Her own book, *Patti Smith Complete: Lyrics, Reflections and Notes for the Future*, is filled with photographs of her pastimes as well as other images of interest to her from personal archives. She has long appreciated the intensity and emotion of photographs. A visual artist herself, Patti Smith knows well the power of images in her life and in her dreams.

It is always a wondrous thing to see fine photographs of significant artists-in-the-making. In the visual archives of rock and roll, there are some classic examples of this, such as Al Wertheimer's photographs of Elvis Presley in 1956, Astrid Kirchherr's photographs of the Beatles in Hamburg in 1961, and Dan Kramer's photographs of Bob Dylan in 1964. Their extraordinary images document decisive moments in the transformation of those artists into icons. Like Wertheimer, Kirchherr, and Kramer, Frank Stefanko was fortunate to be in the right place at the right time. But it's more than good timing that makes Stefanko's photographs of Patti Smith resonate so beautifully. There was a crucial connection between the subject and photographer that brought about these compelling portraits of Patti and the Patti Smith Group, most of which are published for the first time in this book. With the affection and familiarity of a friendship that began in college and continued through the 1970s, Frank chronicled Patti's journey as an American artist with an intimacy and sensitivity that define what these photos are all about.

In "A Pythagorean Traveler," from her most recent book of poetry, *Auguries of Innocence*, Patti Smith wrote:

> *Beauty alone is not immortal.*
> *It is the response, a language of cyphers, notes and strokes*
> *riding off on a cloud charger . . .*

Frank Stefanko's photographs are among those cyphers, notes, and strokes . . . a language of his own, a response to the artistry of Patti Smith. The images in *Patti Smith: American Artist* are themselves auguries of innocence—a key to her own immortal beauty.

—*Chris Murray, 2006*

ACKNOWLEDGMENTS

Many thanks to: Carol Reed for her constant inspiration and assistance; Chris Murray at Govinda Gallery for helping me attain yet another goal; Carol Huh at Govinda Gallery for all her help and patience; Tom Parente for research assistance; Master printer Robert Asman for his amazing talent; Raoul Goff, Peter Beren, and everyone at Palace Press/Insight Editions for their support and encouragement; Big Daddy Graham, Harvey Holiday, and Hi Lit, for their research assistance; Billy and Gail Silverman for being there in the day and remembering; Ken Tisa, Howie Michaels, and Steven Gomez for living the life and surviving to remember; Lee and Keith Stefanko for continuing to put up with the old man. To my Dad, who, at 101 years old, still tells great stories; my Mom, who, at 90 years old, still laughs at my jokes; Steve Stefanko, who continues to be the best of brothers; Edna Green for her encouragement and enthusiasm for this project; Sue and Dan Reed for helping process my ideas; Colleen Sheehy of the Frederick Weisman Art Museum for encouragement and help on the project; Bruce and Patti Springsteen for their continued support; Mr. Rikki Ercoli for his help; Bob Gruen for his kind words regarding these photographs; Ms. Janet "Chaps" Hamill; Ms. Andi Ostrowe for all her help; Lenny Kaye for his knowledge and contribution; Jay Dee Daugherty, Tony Shanahan, Oliver Ray, Ivan Kral, Barre Duryea, Kimberly Smith, Linda Smith Bianucci—and especially Ms. Patti Smith.

To those who were inspirational over the years and are now no longer among us, I thank Grant Smith, Beverly Smith, Todd Smith, Frederick Smith, Robert Mapplethorpe, Richard Sohl, and Ed Sciaky.

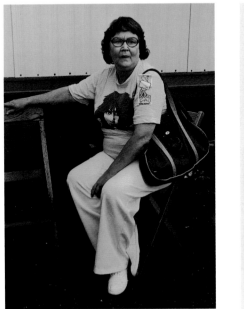 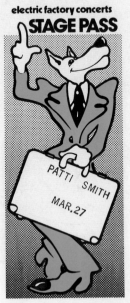

Above: Patti's mother, Beverly Smith, backstage at the Penn's Landing concert in Philadelphia.
Right: The same backstage pass used by Patti's mother. *Opposite:* Jay Dee Daugherty (Patti's drummer), Todd Smith (Patti's brother), and far right, in white T-shirt is Pierre Robert, WIOQ Radio disc jockey in Philadelphia.
Opposite bottom: Patti talking to Ed Sciaky, legendary Philadelphia DJ who, at the time, was also with WIOQ.

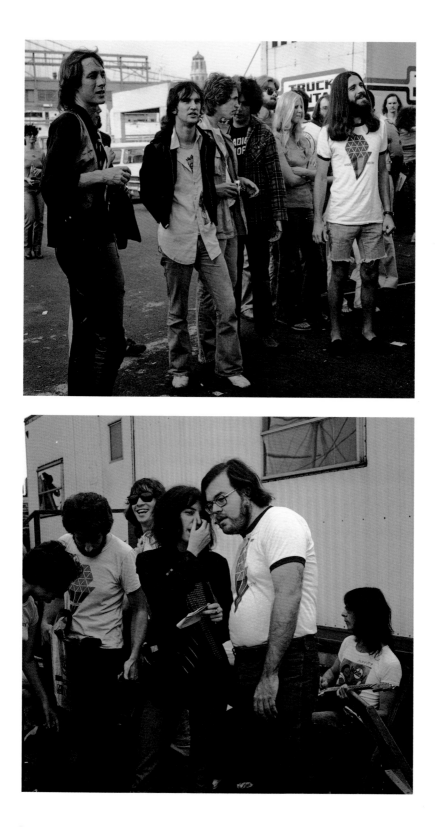

Publisher and Creative Director: **Raoul Goff**

Executive Directors: **Michael Madden, Peter Beren**

Art Director: **Iain R. Morris**

Designer: **Scott A. Erwert**

Design Assistant: **Gabe Wolfe Ely**

Coordinating Editor: **Carol Huh**

Project Editor: **Mariah Bear**

Editor: **Linda Kelly**

Production Manager: **Lisa Bartlett**

Frank Stefanko's photographs are represented by
Govinda Gallery
1227 34th Street, NW
Washington, DC 20007
www.govindagallery.com

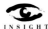

**INSIGHT
EDITIONS**
Insight Editions
PO Box 3088
San Rafael, CA 94912
www.insighteditions.com

Library of Congress Cataloging-in-Publication Data available.

ISBN 978-1-68383-015-3
10 9 8 7 6 5 4 3 2 1

ROOTS of PEACE **REPLANTED PAPER**

Insight Editions, in association with Roots of Peace, will plant two trees for each tree used in the manufacturing of this book. Roots of Peace is an internationally renowned humanitarian organization dedicated to eradicating land mines worldwide and converting war-torn lands into productive farms and wildlife habitats. Roots of Peace will plant two million fruit and nut trees in Afghanistan and provide farmers there with the skills and support necessary for sustainable land use.